BLYTH

THROUGH TIME
Gordon Smith

AMBERLEY

Front cover:
Top: Waterloo Road and its junction with Bridge Street in 1978; *Bottom*: Waterloo Road about 1900. Wright's Timber Yard is now the bus station, the post office hasn't been built yet, and the church in the distance (*right*) is now the DSS and Jobcentre. *Back Cover:* Bridge Street in 1904 and 2009.

First published 2012

Amberley Publishing
The Hill, Stroud
Gloucestershire, GL5 4EP

www.amberley-books.com

Copyright © Gordon Smith , 2012

The right of Gordon Smith to be identified as the
Author of this work has been asserted in accordance
with the Copyrights, Designs and Patents Act 1988.

ISBN 978 1 4456 0852 5

British Library Cataloguing in Publication Data.
A catalogue record for this book is available from
the British Library.

Typeset in 9.5pt on 12pt Celeste.
Typesetting by Amberley Publishing.
Printed in the UK.

Introduction

The town of Blyth is not a very old town like its big neighbour Newcastle. When Blyth became the Borough of Blyth in 1922, the motto on its coat of arms was 'We Grow by Industry'. The town began its 'modern' life in the mid-nineteenth century as a port, and as the port developed, so did the town. The land surrounding the port was owned mainly by the Ridley family and the trustees of the Thoroton and Croft estate. These three names can still be found in the names of streets and some of the buildings.

One of the earliest industries here was shipbuilding and, of course, mining. Both industries that are long gone, but that still remain in the minds of the older generation. As technology changed, mines got deeper and ships got larger, so Blyth expanded. The focus of the town moved from the quayside as land became available; the river that flowed through the town was piped and the land reclaimed.

Religion also played a part in the town's development. While a small chapel of ease was originally the only place of worship, many fine churches were built from 1861 onwards. As their congregations grew, new churches were built to replace the older buildings, which became commercial properties. Many churches have disappeared now but some fine examples still remain, notably the Church of Our Lady and St Wilfrid on Waterloo Road, designed by A. M. Dunn of Newcastle.

The Links, which ran from what is now Ridley Park all the way to Seaton Sluice, were gradually built on as the port expanded, until 1924 when the council bought the land and created the promenade, on what is one of the finest beaches in the county, or possibly the country. In the past decade more improvements were made in this area, and the gun battery built during the First and Second World Wars has been transformed into a visitor attraction. Volunteers man the battery during the summer months, and since its opening to the public in 2009

they have entertained people from all over the country with special exhibitions at which re-enactment enthusiasts display their military vehicles and other memorabilia.

This book aims to show some of these changes through photographs tht have been collected since the 1950s when two teachers began amassing postcards and photographs to illustrate their local history lessons.

Blyth has much to be proud of in its past and also in the present day. Changing from a major coal exporter to a centre for renewable energy, Blyth has a bright future to look forward to.

<div align="right">

Gordon Smith

2012

</div>

Acknowledgements

'Bill' Dawson and 'Bob' Morley, who started the local collection of photographs. Syd Soulsby, who took many of the colour slides used. Messrs. G. W. Baker, H. O. J. Bedgood and Les Towers, of Blyth Photographic Society. Ray Dunn, *Blyth News* photographer. Bob Balmer OBE, Blyth Local History Society. The Port of Blyth. Blyth Public Library. And everyone, over the last fifteen years or so, who has loaned or given photographs and postcards to copy.

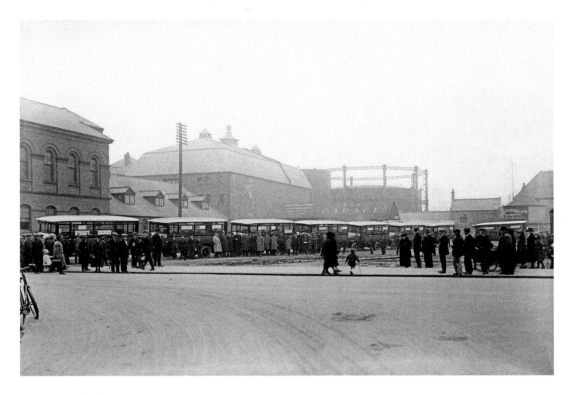

Bus Station

Wright's timber yard moved from here to the new Import Dock between 1905 and 1907, and the area has been used as a bus station from about 1923. Below, this area was intended to be for the proposed Town Hall and known as Town Hall Square. It was later called Post Office Square. By 1954 the area had been landscaped.

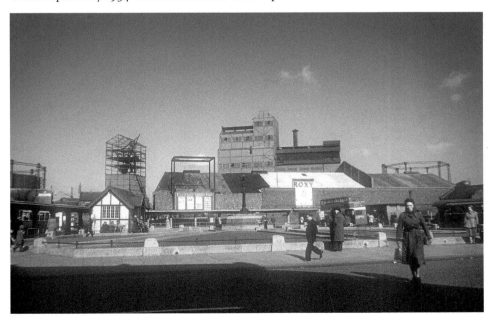

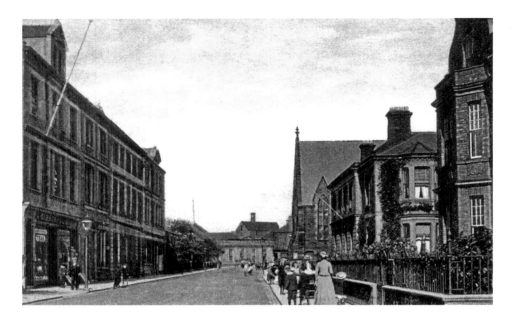

Bridge Street

Formerly New Bridge Street, the buildings on the right were built between 1876 and 1889. There were three banks here: the first two buildings on the right and Lloyd's on the left. At the end of the street is the Blyth & Tyne Brewery Bar, with the brewery behind. The original houses are behind the trees on the left. It was here that Dr Gilbert Ward, the man responsible for creating a hospital in Blyth, lived. The houses and church were demolished in the early 1960s.

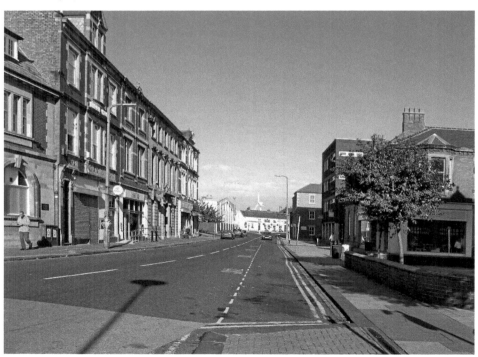

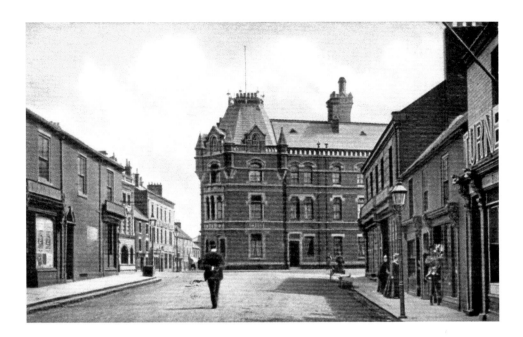

Blagdon Street

Now renamed Bridge Street, Blagdon Street is seen here before 1912 and, fifty years later. John Wallace, Blyth's first historian, wrote in 1862: 'The town had been built with a singular disregard to plan....and must have had a strong aversion to continuous lines of streets.' This is nicely illustrated here, where Blagdon Street 'dog-legs' into Northumberland Street by the police station. The buildings on the left were demolished to build the Blyth Harbour Commissioner's offices and houses.

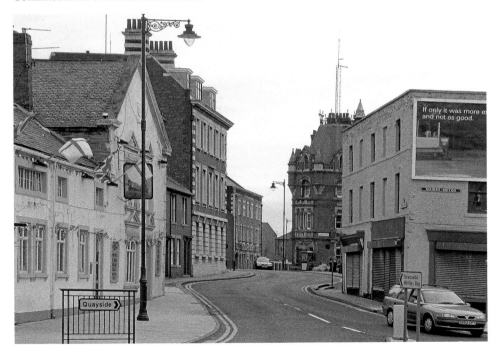

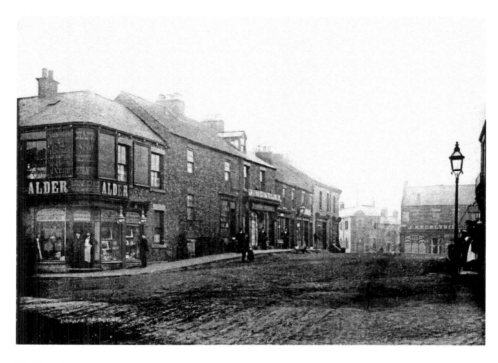

Market Street

Turning left into Market Street (now called Plessey Road), we look back towards Blagdon Street and the 'new' post office, built in 1893. Mr Alder also ran a printing business in Sussex Street (*left*).

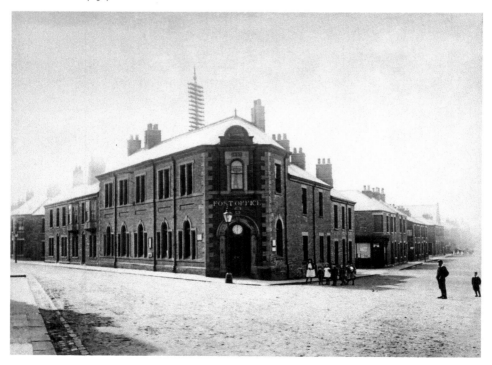

Plessey Road

At the bottom of the street on the left was the Drill Hall of the Elswick Battery, Royal Artillery, Territorial Army and 272nd Northumbria Regiment. Two T & B Coaches are ready to take the children on an outing to Crimdon Dene on 20 August 1960. The South Side staiths are in the background. By January 2009 the quayside area had been redeveloped into a pleasant walkway. The Drill Hall and staiths have gone, and the Alcan Terminal is on the north side of the river with the *Arklow Wind* unloading alumina.

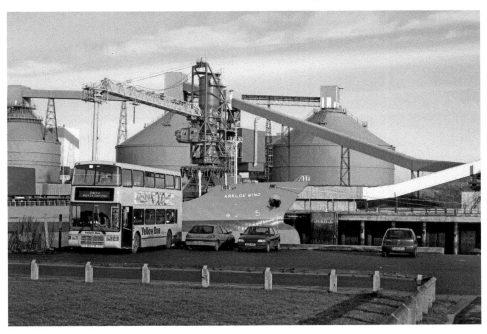

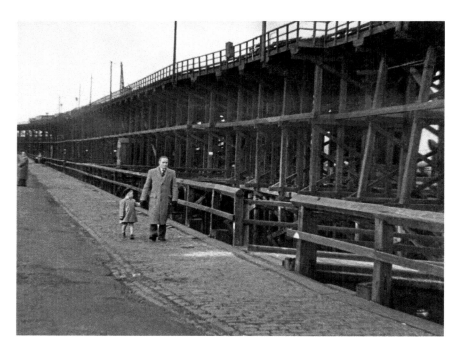

Low Quay Road

Dave Allen strolls along the quayside with his father Joe, a merchant navy engineer, and is more interested in what is happening on the river than posing for the camera. In the mid-1990s the regeneration of the quayside began and continues today. In June 2008 a Maritime Festival was held here. On the right is the art work *The Spirit of the Staithes.*

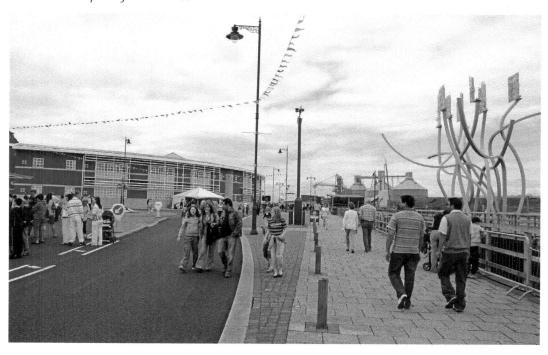

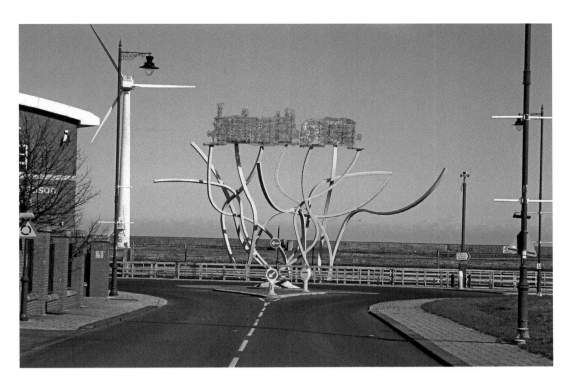

The Spirit of the Staithes

This artwork represents a coal train running on the staiths, standing the same height as the original staiths. It is best seen from the traffic island by the Oddfellows Arms. Looking in the opposite direction in 1920, the building on the left was the original Customs House, with the 'new' 1890 Customs House on the right.

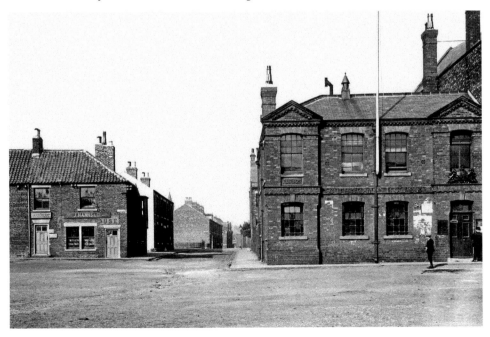

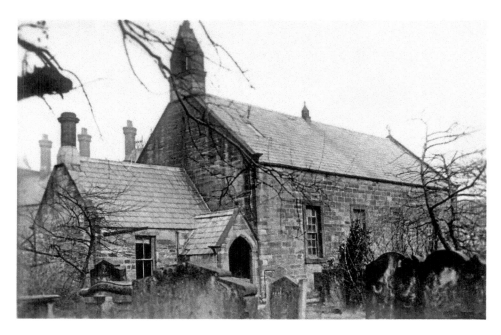

The Chapel of Ease

Built in 1751, the chapel of ease was used as the church hall for St Cuthbert's Church until the new hall was built in 1925. The keystone from the chapel is incorporated in the arch of the present church hall.

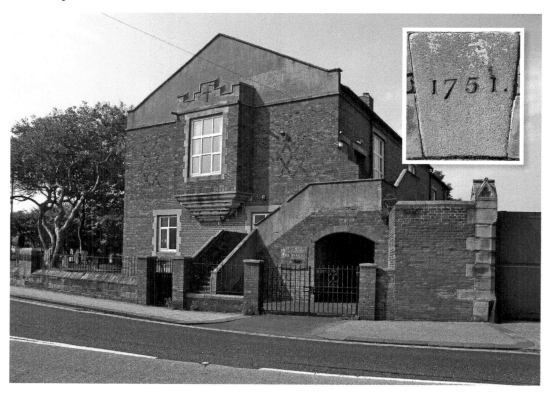

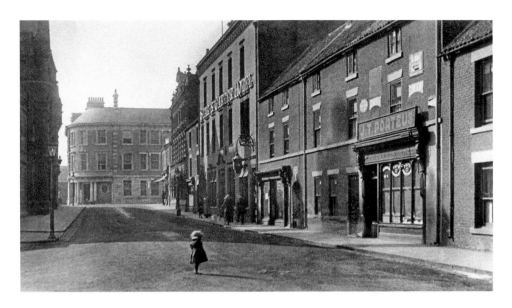

Northumberland Street

Today known as Bridge Street, with the Blyth Harbour Commissioner's offices and the King's Head and Star & Garter Hotels on the right, opposite the police station. In between the two shops is Smith's Buildings, damaged by a bomb during the Second World War and demolished in the 1949. Both hotels are now closed. The Star & Garter Hotel was renamed the Steamboat in 1967, and is undergoing refurbishment to become an office building. The King's Head is currently up for sale.

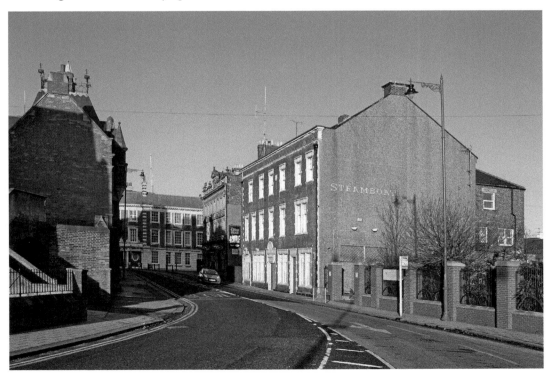

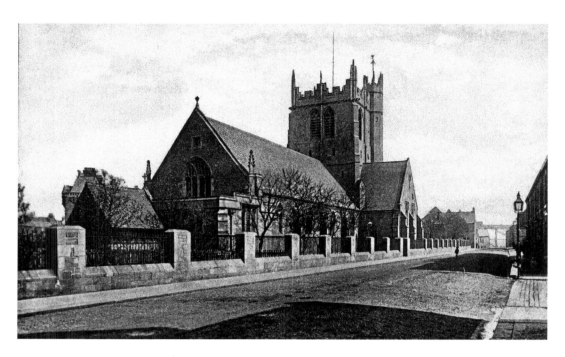

St Cuthbert's Church

At the junction of Wellington Street and Plessey Road is the church built to replace the chapel of ease. The pinnacles on the tower were removed after a gale in 1938. The South Side staiths are in the distance.

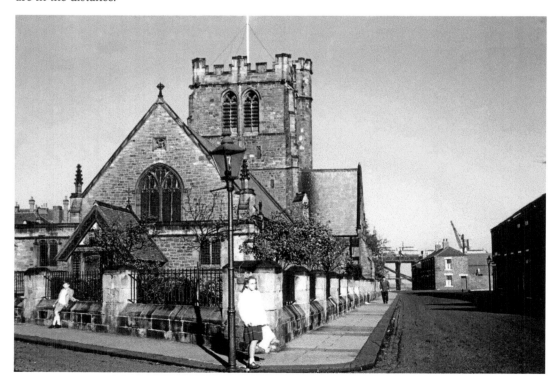

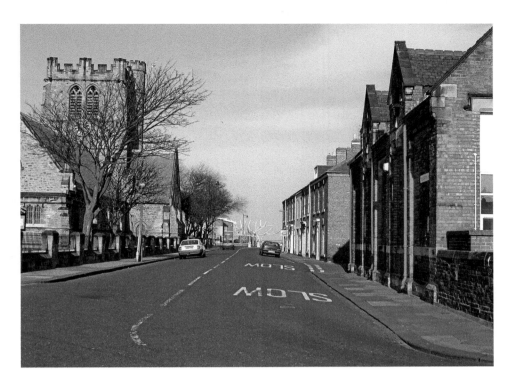

Plessey Road School
This school, built in 1892, was recently demolished and sheltered accommodation was built in its place. Hadrian Health Care homes now stand on the site of the school, at the junctions of Plessey Road (*left*), Percy Street (*right*) and Wellington Street running past St Cuthbert's Church.

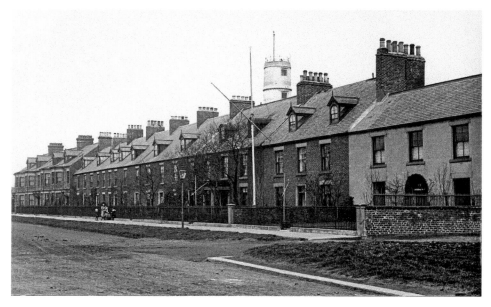

Bath Terrace

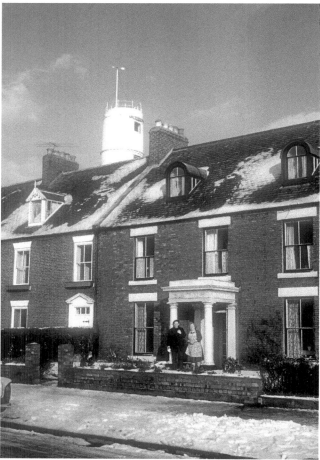

This is one of the older parts of Blyth, built in the 1780s. It is unusual in having a lighthouse in its back lane. The lane was named after the bath house, which provided hot, cold and vapour baths. It is now a private dwelling. In front of this house stand Watson Brown and his mother, who lived there in the 1950s. The street was once known as Shiney Row, or sometimes Paradise Row, because when the houses were first built there was nothing between them and the river, so the sun rose and shone on the windows.

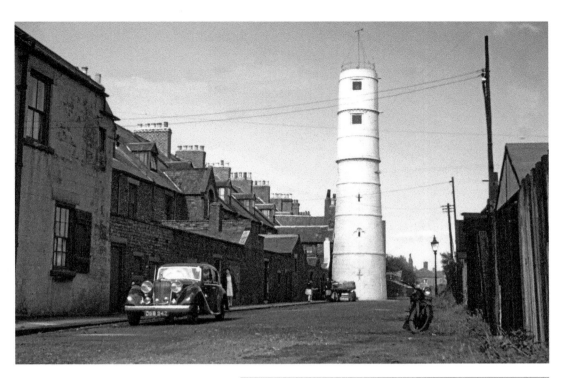

The High Light

Not strictly speaking a lighthouse, this leading light was navigational aid for shipping. Originally the light was an oil lamp but was changed to gas in 1857. In 1888, because of the building of staiths on the south side, it was extended by 4 metres. In 1900 it was extended another 4 metres because of the rebuilding of the staiths, and later it was lit by electric light. It was still in use as a leading light until 1984 when the 'new' High Light was erected after the building of No. 14 Transit Shed, which obscured the line of sight. In 2011 the High Light was moved again to the other side of the road. The shed to the right was originally the stand at Gateshead Football Stadium.

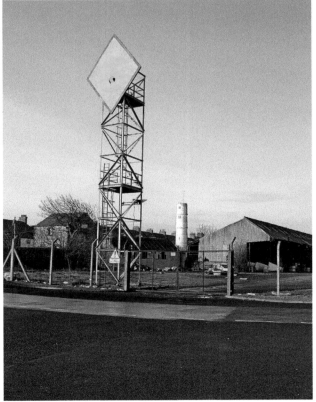

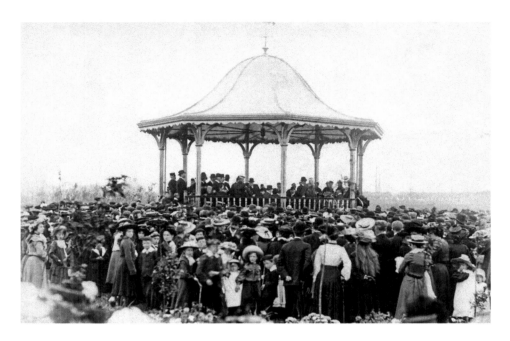

Ridley Park

The park was opened by Lord Ridley on Wednesday 27 July 1904, when he was presented with a gold key as a memento. During the afternoon selections of music were given by the Seaton Delaval Military Band. After sixty-five years this bandstand was removed and a rose garden created on the spot, opened on 2 June 1970. Outdoor Leisure & Amenities Manager, Ken Earnshaw, who designed the garden, stands on the extreme right.

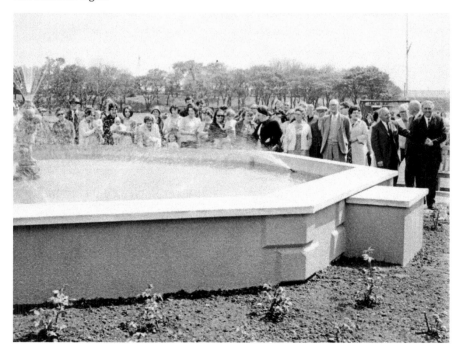

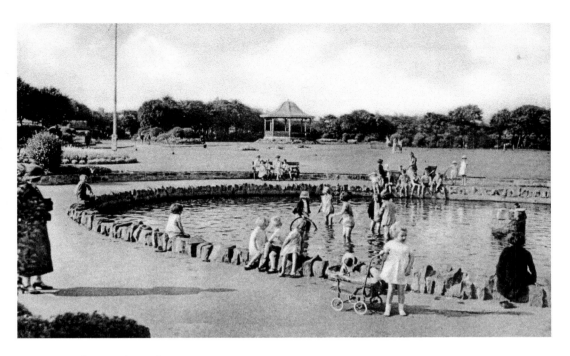

The Boating Lake

Another feature of Ridley Park was the boating lake, which caused the local council much trouble as the water wouldn't stay in it. The problem was eventually solved and the lake was popular with children in the summer months as a paddling pool. By the 1960s the park had another facelift and the pool was made into a more modern paddling pool that was easier to keep clean, seen here in 1968.

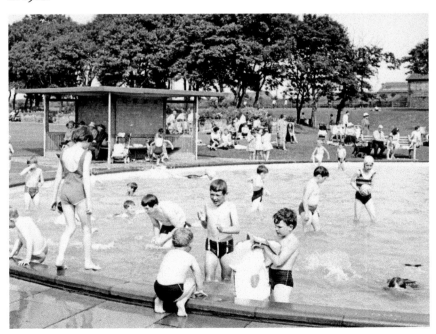

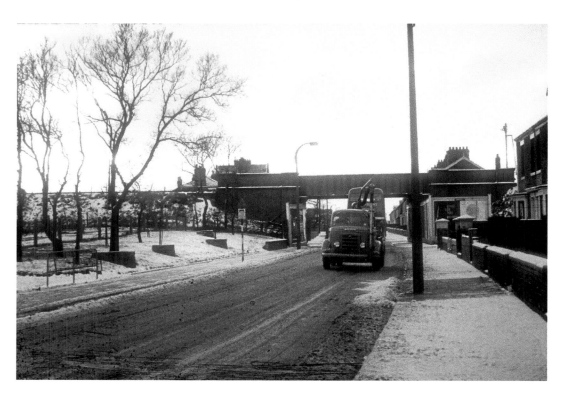

Belgrave Crescent

Running alongside the park on the road to the beach is Belgrave Crescent. Until the late 1960s, when entering Blyth from any direction by road you had to pass under railway bridges like this one, which divided Belgrave Crescent from Wensleydale Terrace. The bridges were removed when trains stopped running from Blyth.

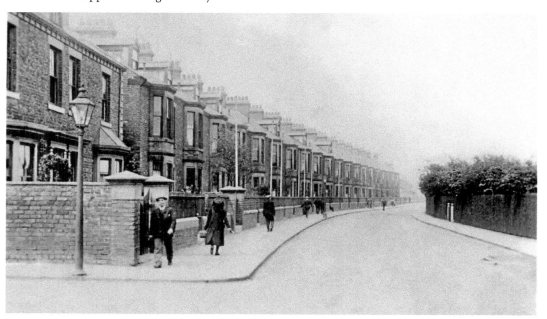

Wensleydale Terrace
Photographed in the 1920s, looking towards Ridley Park. The fence on the right was the timber storage yard for G. & N. Wright after they moved here from Bridge Street near the town centre.

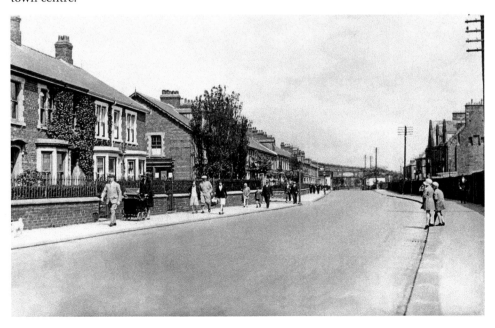

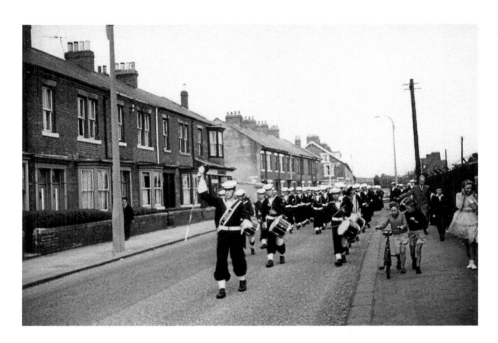

The Wellesley Nautical School

Every Sunday morning the Wellesley Nautical School Band could be seen marching to church and returning along Wensleydale Terrace to their school in the former First World War naval base, near the present entrance to the South Harbour. Known as HMS *Elfin* during the Second World War, the naval base is pictured below in 1999. The site has now been cleared for a housing development.

Import Dock

Old South Harbour entrance in the 1960s. The two houses were knocked down to allow for new transit sheds and the entrance relocated further along the same road. Below we see the new entrance to the dock on the Link Road. On the right was another timber yard, now a caravan storage park.

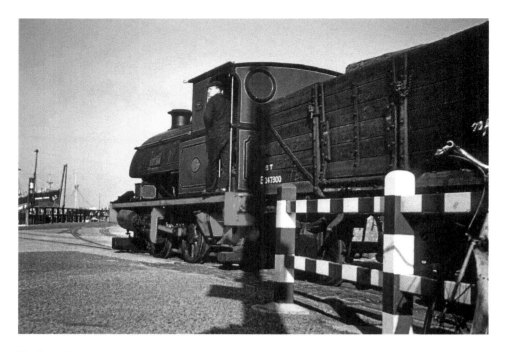

Harbour Locos

Above is Blyth Harbour Commission saddle tank engine *Pony* in the Import Dock, South Harbour, in 1963. The Commission's two engines were replaced with a diesel for a few years and scrapped. Below we see BHC engine No. 2 with its diesel replacement in 1971. Made in 1912, No. 2 was bought by its makers, Hawthorn, Leslie & Co. of Newcastle, in 1971 and restored. Renamed *Ajax*, the 100-year-old engine now takes tourists around Chatham Dockyard in the summer months.

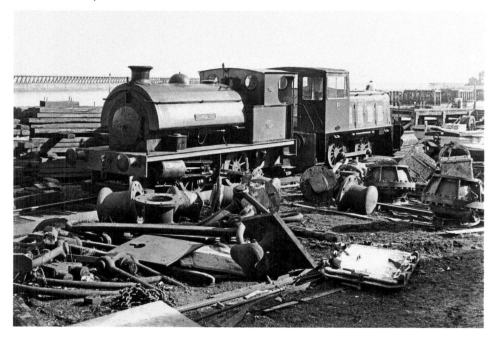

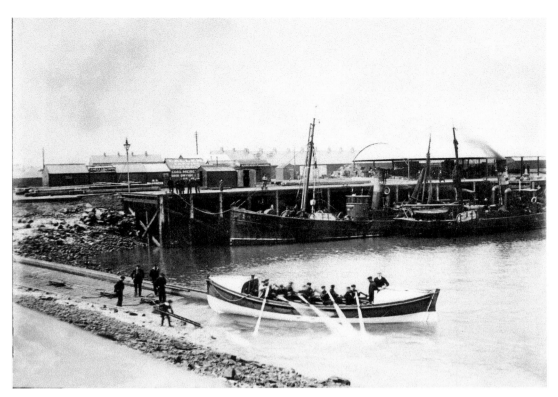

The Slipway

In 1898, the Blyth lifeboat house was built in the Import Dock and also a slipway to launch the *Dash*, the last of the man-powered lifeboats in Blyth, where a lifeboat has been stationed since 1808. In the photograph to the right, from 1962, a Flying Osprey from the Royal Northumberland Yacht Club is using the slipway. The brick building was the gas decontamination centre for the naval base during the war. The shed to the right was built before the First World War for the fishing industry, which started about 1905, ended when the war started and didn't revive after the end of the war in 1919. There are still a few vessels fishing from Blyth, mainly small locally owned boats, but not on the pre-war scale.

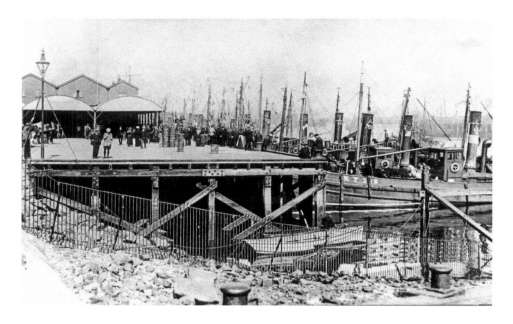

The Fish Quay

Before the First World War there was an attempt to create a large fishing trade and this quay was built to accommodate this industry. On the outbreak of war the trawlers were requisitioned by the Navy and that was the death knell for the trade. Today there is a roll-on roll-off pontoon and the quay has been strengthened to take containers, etc. Tied up around the Sto-Ro are the pilot launch (left), and the port's tug *Endeavour*. The vessel *Seawheel Express* on the west quay is unloading parts for wind turbines to be erected inland.

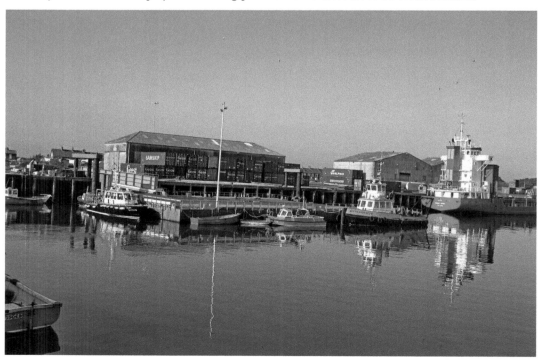

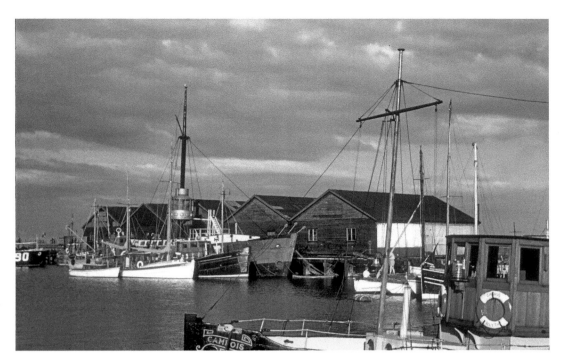

The 'German' Sheds Beside the Middle Jetty in 1952

They had been built for the fishing industry and a German firm, O. Buecker of Geestemünde, used them in 1913, hence the name. The old harbourmaster's steam launch *Cambois* is in the foreground, and the Calshot lightship, moored next to the sheds, arrived in 1952 to be converted into the headquarters of the Royal Northumberland Yacht Club, replacing the two earlier vessels. The house yacht *Tyne 1*, formerly a schooner belonging to the engineer Robert Stephenson, came to Blyth in 1899, where it remained until 1924 when it was beyond repair and had to be replaced.

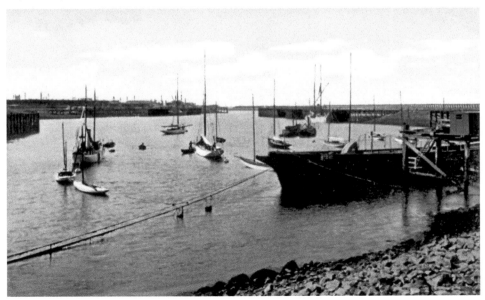

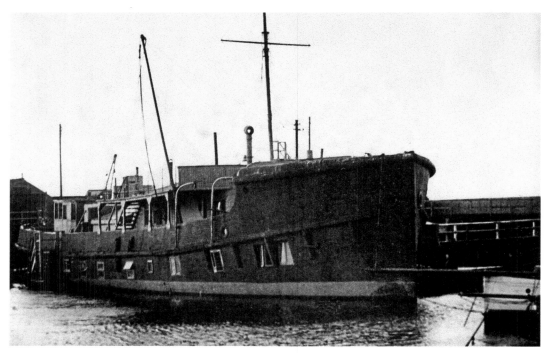

RNYC House Yacht *Tyne III*

Tyne I's replacement was the Admiralty tug *Cretehatch*. This was one of twelve experimental tugs made of concrete between 1918 and 1920. She was brought from Aberdeen and converted to a clubhouse; the large saloon's portholes were made into casement windows. Unfortunately, during a severe gale in 1949 she turned over, and the club was based on shore until light vessel 50 arrived. The house yacht *Tyne III*, formerly light vessel 50, has now now moved from the old Dolphin (on the right) to alongside the Middle Jetty at the South Harbour.

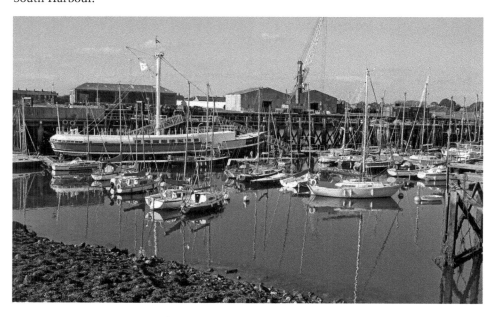

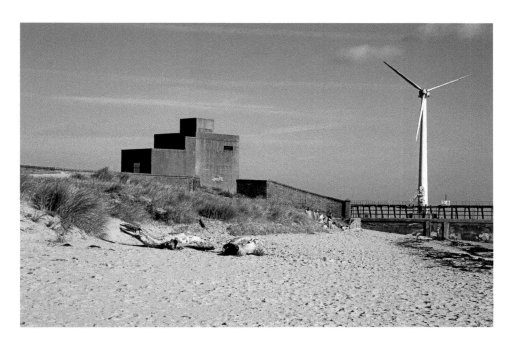

Between the Piers

The area of the beach between the Inner West Pier and the West Pier is probably the safest part of the beach to swim from. In 1992 wind turbines were built on the East Pier, one of which is on the right of the blockhouse, on the opposite side of the river, shortened when the West Pier (right) was built to create a wave spending basin. In 1965 the annual lifeguard competition was held between the piers. This is the Blyth team going through their drill. The two gentlemen carrying the 'body' are (left) Eric Armstrong (presently Coroner for South Northumberland) and Brian Gallon (the previous Coroner).

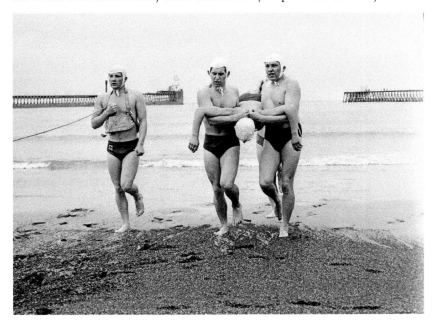

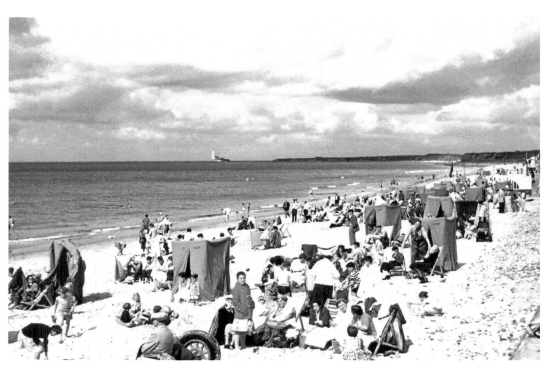

The Beach

Holidaymakers on the beach in the 1960s. The tents and deckchairs were provided by the Borough Council for a small fee. In the distance are Seaton Sluice and St Mary's Lighthouse.

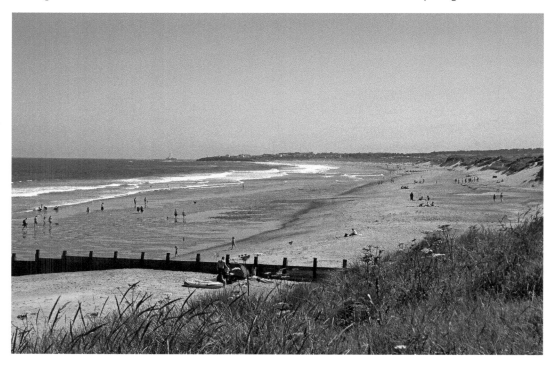

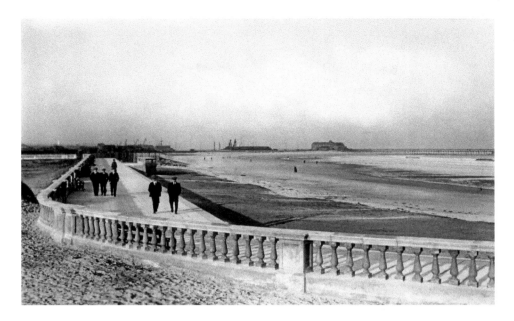

The Promenade

In 1924, the Town Council purchased the Links from Lord Ridley, and took advantage of government schemes to help the unemployed by developing the area to create work. Building the promenade was the first part of the scheme. By 2008, the balustrade was beyond repair, and the council had already started a scheme to redevelop the area.

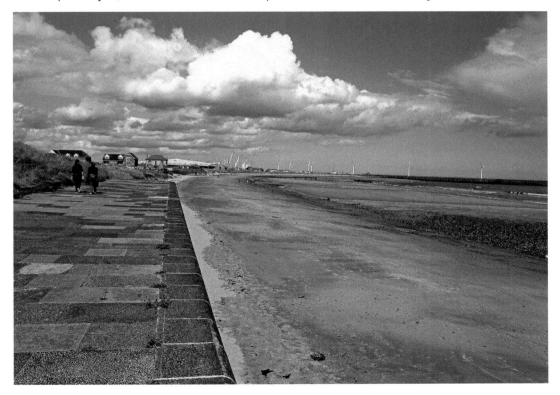

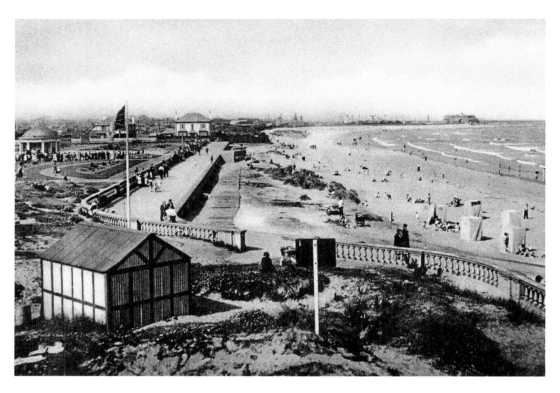

Beach Gardens

After building the promenade, gardens and a bandstand were created, which officially opened in 1928. The building in the foreground was used for the hire of deckchairs and tents. Before the council bought the Links, which stretched as far as Bath Terrace, industrial development covered them, so that by 1904 they started at the Ridley Park Hotel.

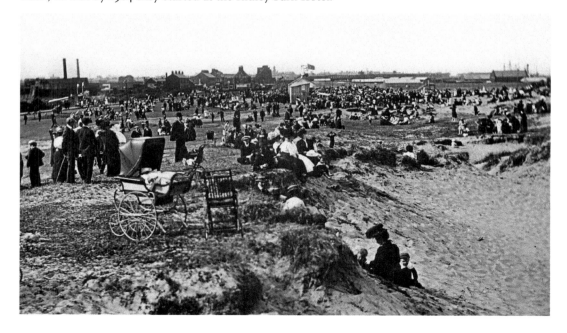

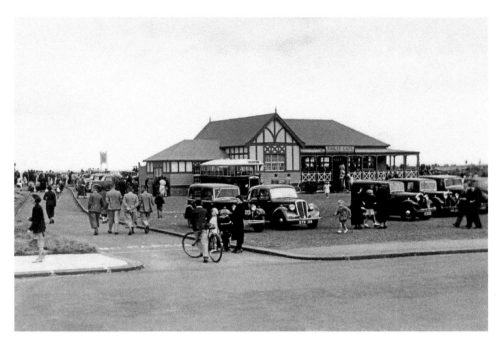

Jubilee Café

The 1935, the Council built the Jubilee Café in celebration of King George V's Jubilee. A playground was created in the 1960s, and to disguise a drainage inspection tower there, they made it in the shape of a ship, the *Landlubber*, to the right of the café.

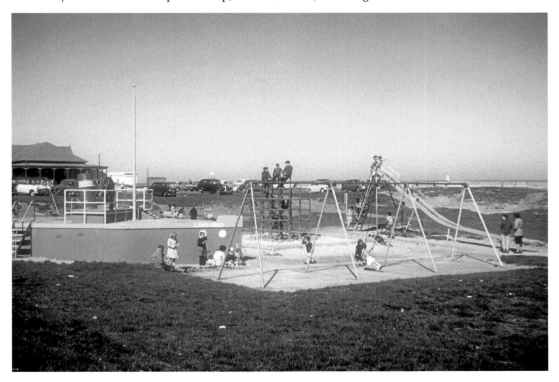

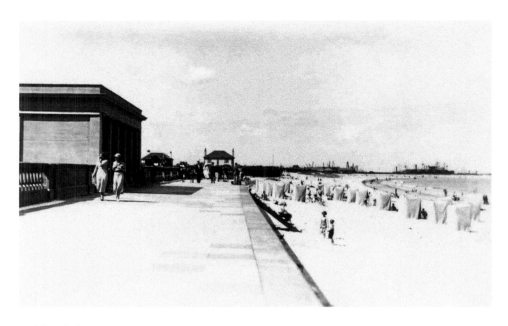

Public Shelters

Another part of the work creation scheme was the building of two public shelters on the promenade. Below, Mrs Florrie Smith and Mrs Ivy Bell shelter from the wind in the 1960s. This shelter can be seen above as it was in the 1930s.

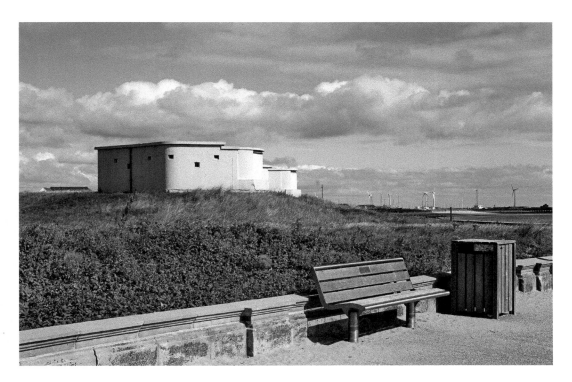

Searchlight Battery

An engine house and two searchlight posts were built in the First World War. After the generators, etc., were removed after the Second World War, the engine house was converted into public toilets. The searchlight buildings were let as beach chalets.

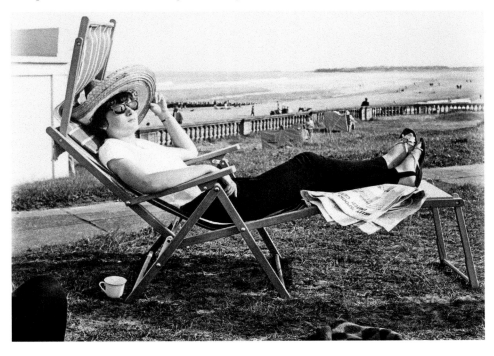

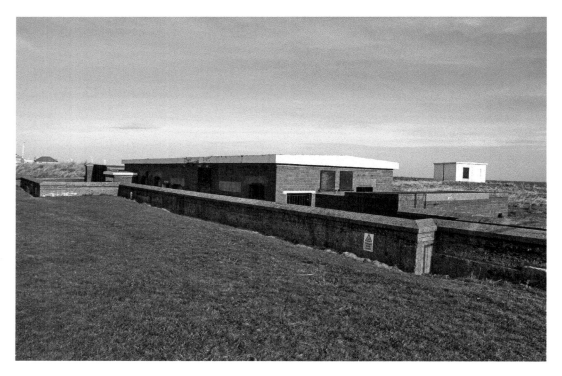

The Engine House

Shortly after this photograph was taken in 2007, restoration of the battery began. The buildings were painted in their original colours, grey for the First World War, pink for the Second World War and white for alterations between and after the wars. On the right of these buildings, in the 1960s, was a crazy golf course.

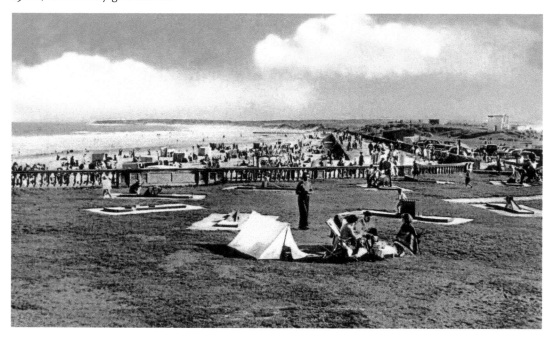

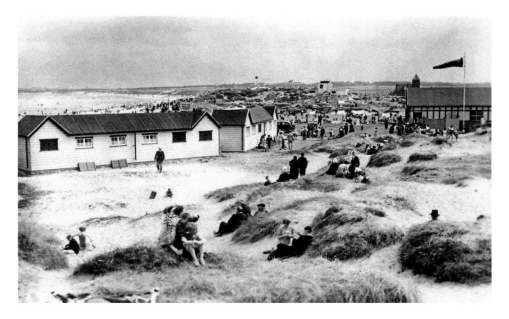

Blyth Battery

The battery in the 1930s, with the battery buildings in the distance. Looking the other way from the dunes, from the left are Fort House, the roof and railings of the shelter building, the First World War Battery Observation Post, and the Second World War Battery Operation Post. Towards the foreground is the south gun emplacement, repaired in 2008, and now a visitor attraction.

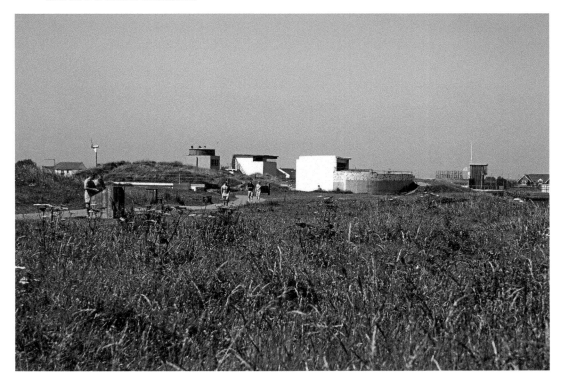

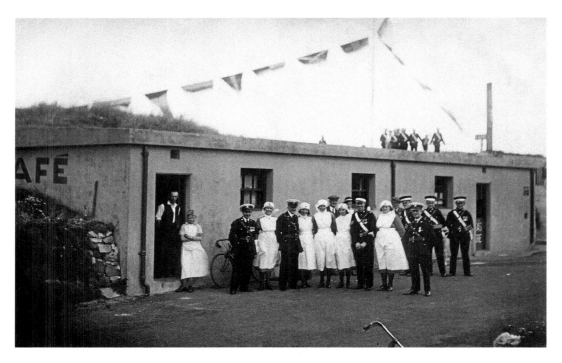

The Shelter Building

Between the two World Wars, the shelter was used as a café and the St John's Ambulance Brigade had a post here. It is now a café–museum displaying wartime artefacts donated by the public, and is run by the Blyth Battery Volunteers. Below we see the shelter following restoration work in 2009.

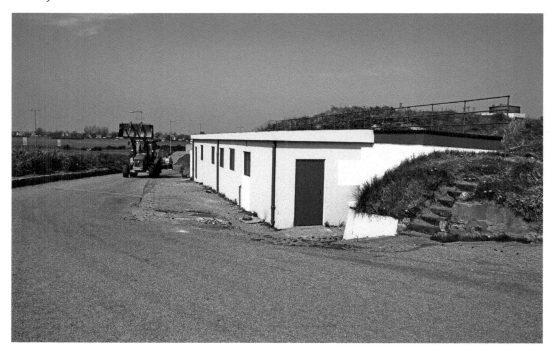

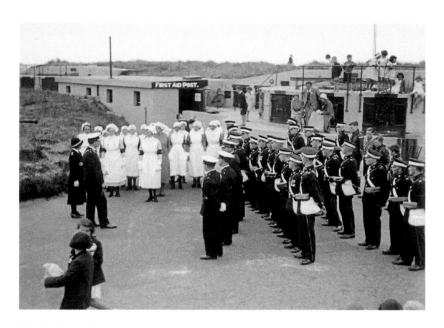

St John's Ambulance

Above we see a St John's Ambulance Brigade inspection taking place in the 1930s. Below, Inside the shelter, the 'Time Bandits', in Second World War costume, greet visitors in May 2011. On the left is a SJAB nurse's uniform.

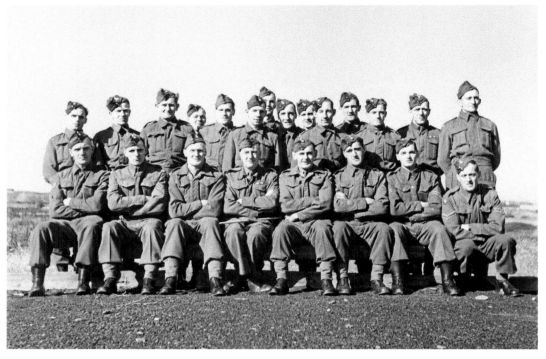

The Magazine

The Blyth Home Guard manned the battery for much of the war. The magazine, with three of the battery Volunteers outside, houses more military memorabilia and a display board about the battery. The volunteers also give guided tours of the site to members of the public, schools, etc. These tours are free of charge.

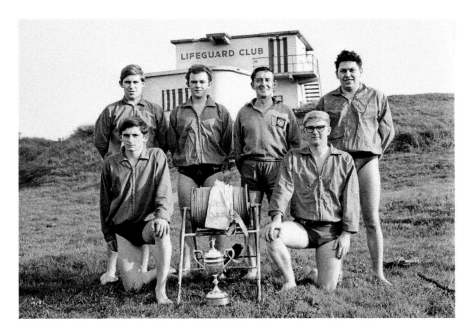

Second World War Battery Observation Post

In the early 1960s, Blyth Lifeguards took over the old observation post to watch out for swimmers in distress during the summer season. Now in the summer months, the Battery Volunteers show visitors around the building, and the lifeguards have a new headquarters.

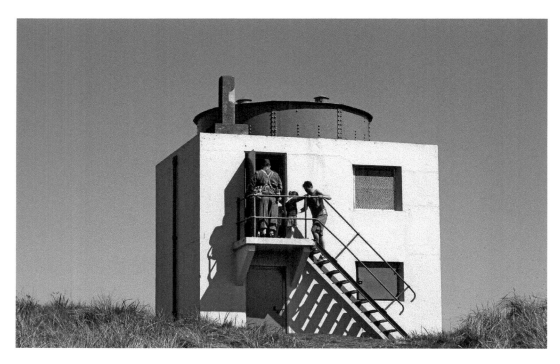

First World War Battery Observation Post
A Battery Volunteer shows visitors the First World War Battery Observation Post with its unique revolving turret. The ground-floor interior is now a replica of a 1940s house created by the volunteers, with artefacts and toys donated by the public.

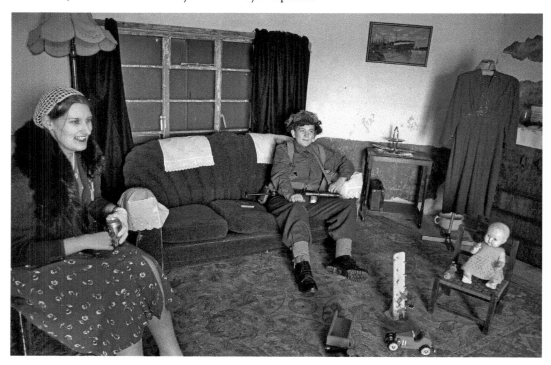

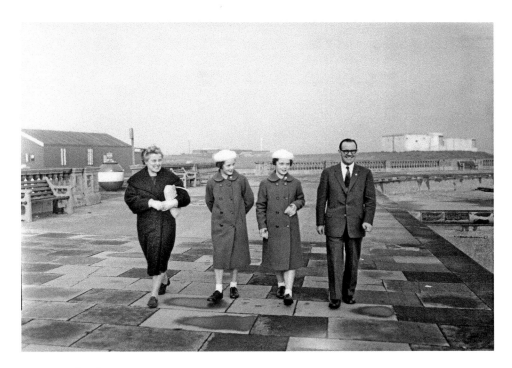

Dave Stephen's Centre

Newly elected Member of Parliament for Blyth, Mr Eddie Milne takes a tour of his new constituency with his family, in October 1960. By 2008, new facilities were required near the promenade, and the Dave Stephen's Centre was built and officially opened in March 2009.

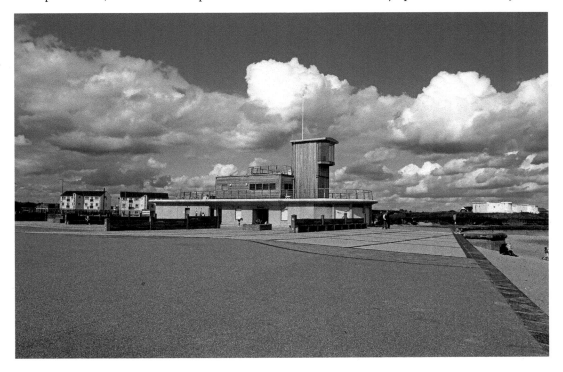

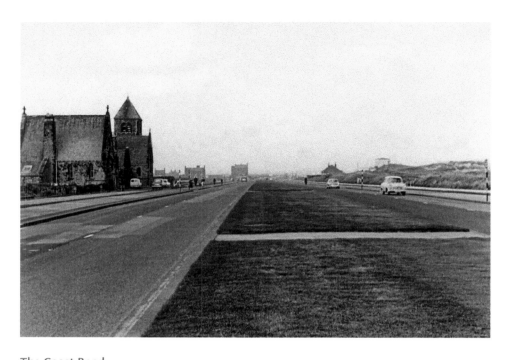

The Coast Road

The Blyth Link chapel and cemetery opened in 1861. The coast road was built as a job creation scheme in the 1930s. On the left are the Link House Farm and the Link House. This dual carriageway was intended to take traffic away from the centre of Blyth. Below, the Link House in 1924 when the borough council took over the Links.

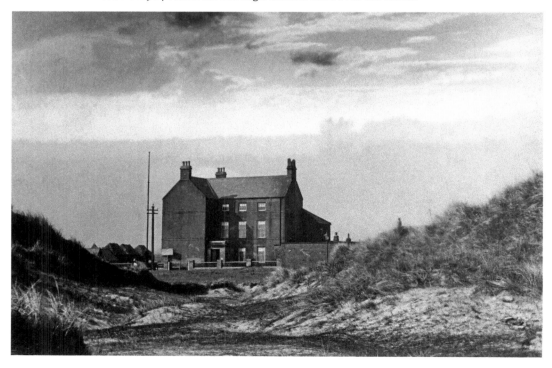

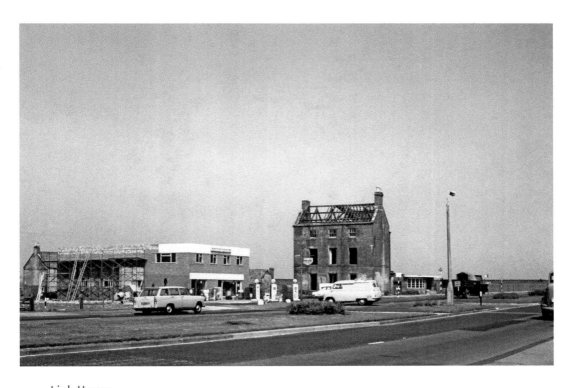

Link House

The demolition of the Link House in 1965. The garage being built is still in use, and a restaurant and ice cream parlour have been erected on the site of the Link House.

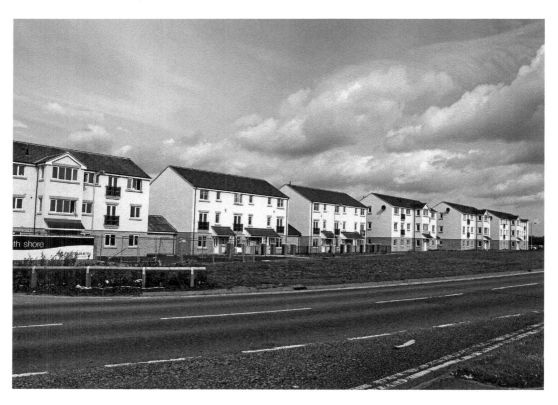

South Shore

These recently built houses are on the caravan site that developed here in the 1960s, but even earlier in the 1920s and 1930s this area was a popular campsite for holidaymakers.

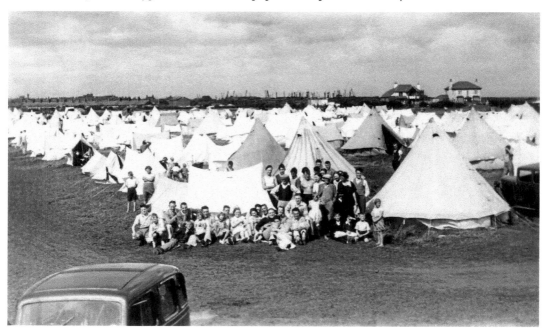

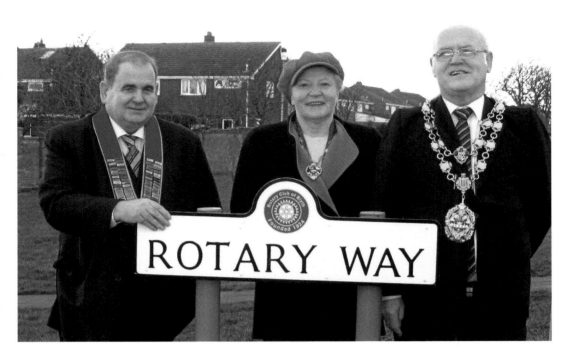

Rotary Way and Plessey Road

On the other side of South Shore is Rotary Way, a road that runs from the beach back into Blyth. New signs were place there to commemorate Rotary's eighty-fifth anniversary. Above are President of Blyth Rotary, G. Robson, and the Mayoress and Mayor, Mrs and Mr Knox. Plessey Road divides Rotary Way from Broadway. Blyth Grammar School was built here in 1912, and demolished in 2011. Here we see the school in 1962, shortly before it became New Delaval School in 1965.

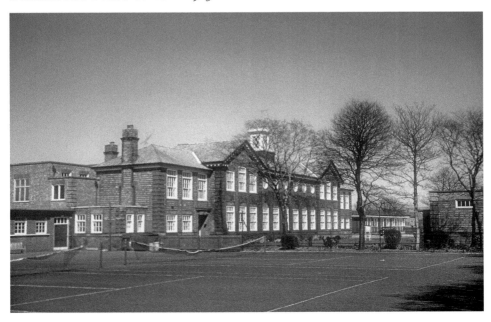

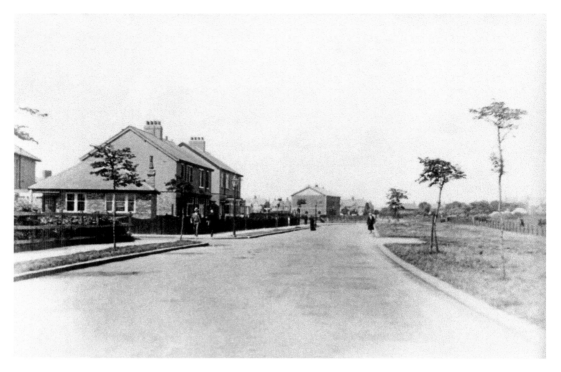

Broadway
Opposite Rotary Way is Broadway, which looked like this in the late 1920s. The area on the right was to be the other lane of the proposed dual carriageway. The building near the centre was the Miner's Welfare, built in 1926 and now used by the County Council.

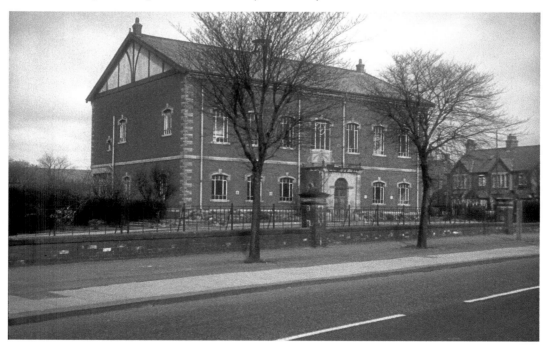

Broadway Circle
Broadway joins Princess Louise Road and Renwick Road at this roundabout, which has an army cadet training HQ, seen on the left. The Majestic Jazz Band is marching from Waterloo Road (*right*) towards the roundabout.

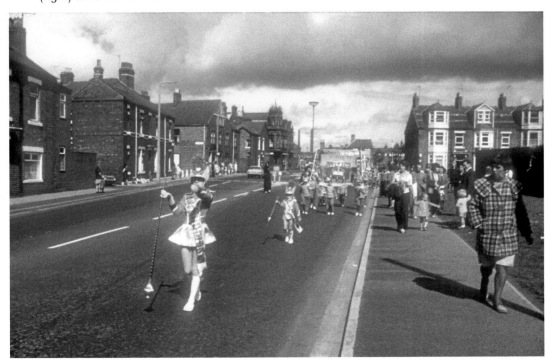

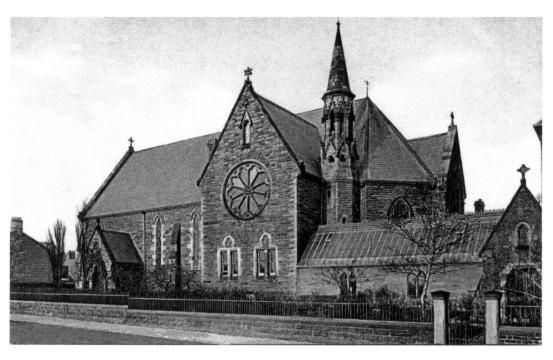

St Wilfrid's RC Church

Near the top of Waterloo Road is the RC Church of Our Lady and St Wilfrid, which opened in October 1862. The presbytery was linked by a cloister to the church in the 1870s. This interior view is from around 1880.

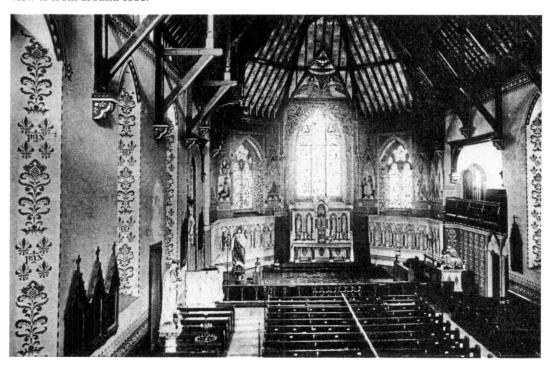

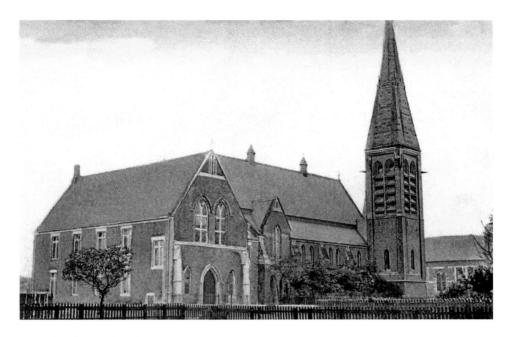

United Reform Church

Opposite St Wilfrid's is this church. Built as the Waterloo Presbyterian Church and opened in 1876, it became the United Reformed Church in 1980. The spire was a landmark for ships entering the port of Blyth. It closed in September 2009, but the congregation still worship in St Wilfrid's presbytery, across the road.

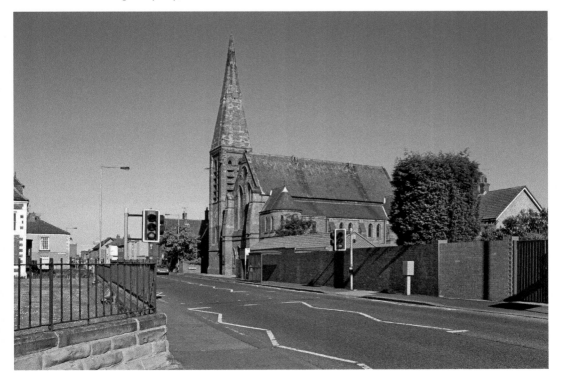

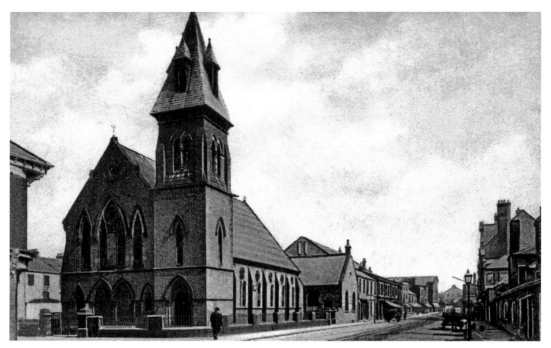

Zion Methodist Church

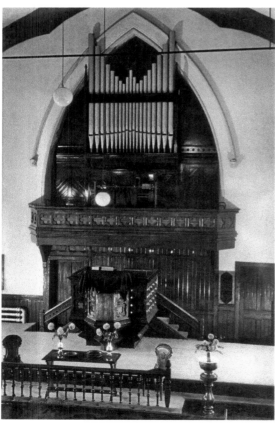

Beside the Market Place on Waterloo Road stood this church built in 1866. The spire was removed after it sustained bomb damage during the Second World War, and the church was demolished in the 1970s. Below, the interior of the church is pictured after renovation in 1949, following wartime bomb damage. The front of the church was remodelled and the choir gallery removed. The communion table and chairs were dedicated as a memorial to those killed in the Second World War.

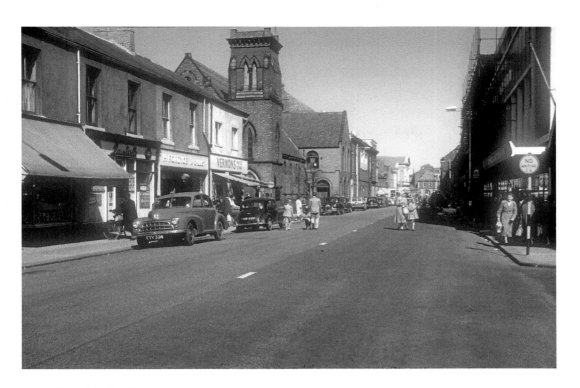

Waterloo Road

Here we see Waterloo Road at a time when traffic wasn't quite as busy as it is today. Seen from the air in the 1920s is the same area, with St Mary's Church, the Market Place with the Zion Church diagonally opposite St Mary's, Turner Street, Bridge Street and at the top the Theatre Royal and the Hippodrome Cinema.

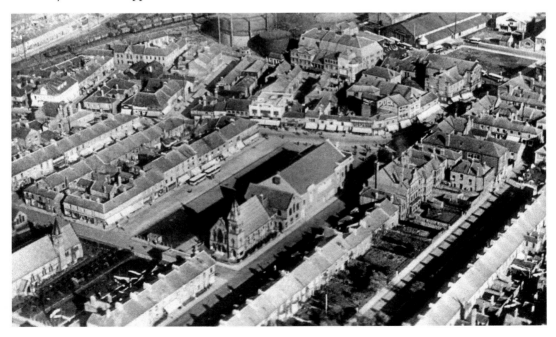

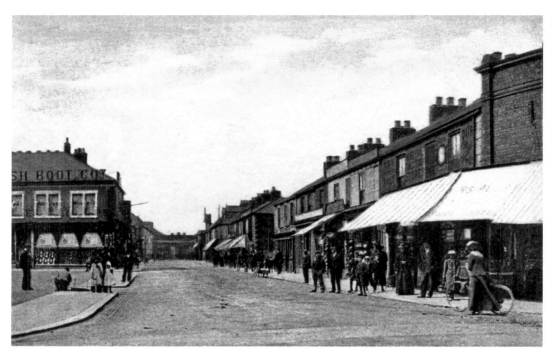

Turner Street

Joining Waterloo Road and Bridge Street, some of the shops on the right were demolished in the 1990s to make way for the Keel Row shopping centre in September, 2009. The entrance to the shopping centre is on the right.

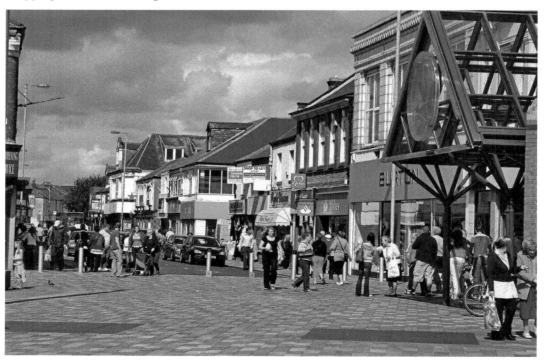

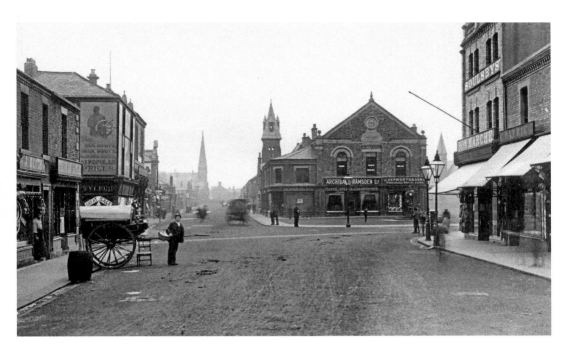

Central Buildings

The Central Buildings stood on the corner of Waterloo Road and Turner Street from 1858 to 1923. The spires of three churches, left Presbyterian, centre the Zion and right St Mary's Church at the top of the Market Place. By 1924 the Central Cinema (shown in 1938) was on this site. It was demolished in the 1970s, after having been a bingo hall for a few years.

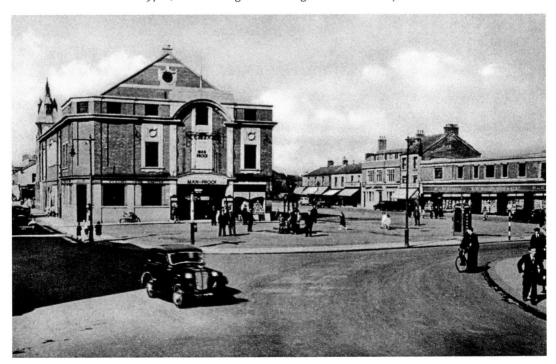

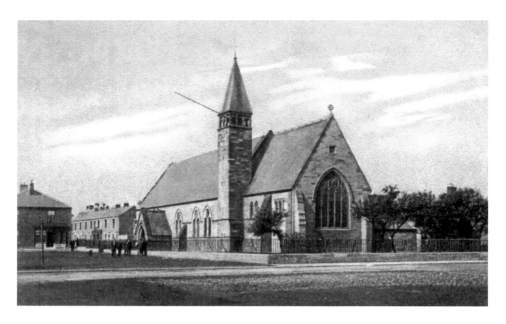

St Mary's Church

Standing at the top of the Market Place, and opened in 1864 and extended in 1897, The church is still in use today. To the left is a submarine anchor, a memorial to the submariners who sailed out of Blyth in two World Wars. The path by the church is named Elfin Way, the name of the Blyth submarine base during the Second World War.

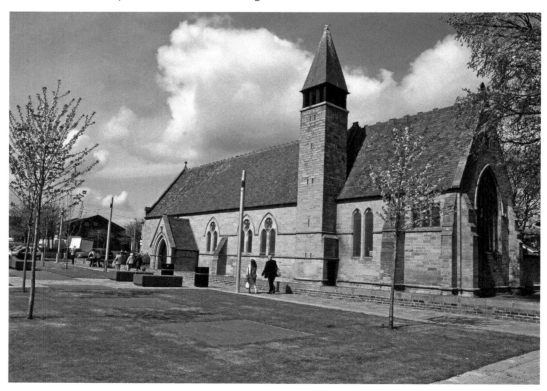

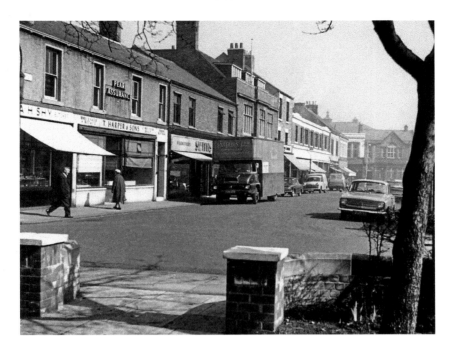

Market Street

Here we are looking from the church towards Turner Street in the 1960s. From the left is Shy the butcher's, Harper's fish shop, Smith's furniture shop, Market Hotel, Soulsby's the butcher's, Woolworths, Morris the jeweller's, and Dean's florist's. The photograph below was taken in October 2007 just before the regeneration of the Market Place started the following month.

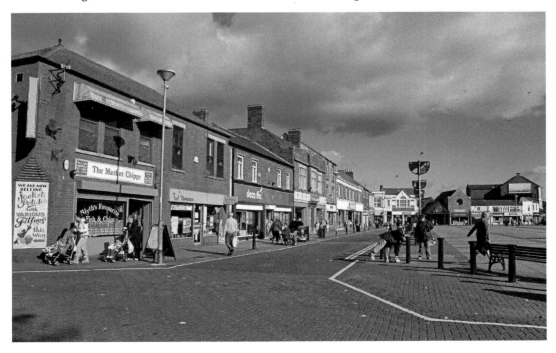

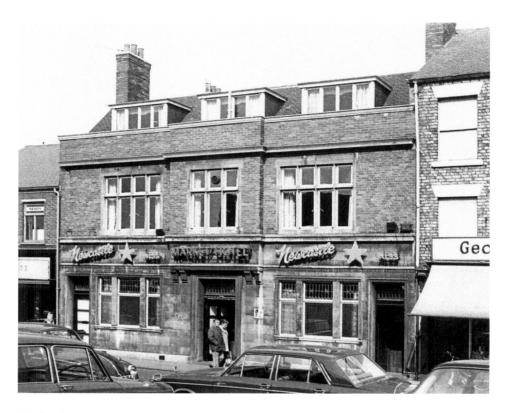

Market Inn

In the centre of Market Street was a public house run by Henry Bonner (seated, with cricket trophy). The barefooted urchin picking his nose seems unimpressed. Remodelled in October, 1927, it closed in 1982 and became a shop.

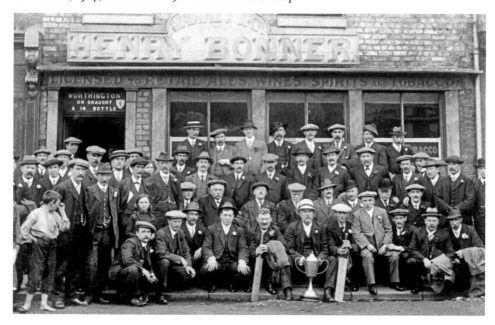

Turner Street

Built as a church in the 1860s, it became a shop by the 1880s, when a new church was built in nearby Bowes Street. Joseph Lee owned the shop in 1904. On the corner of Simpson Street, it remains a shop to the present day.

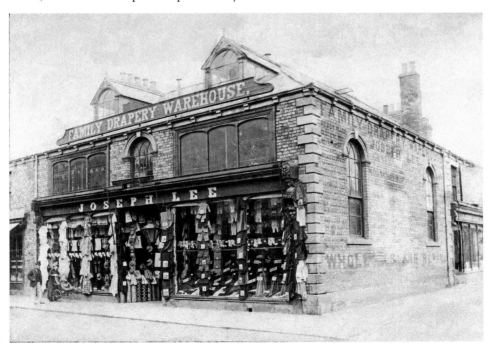

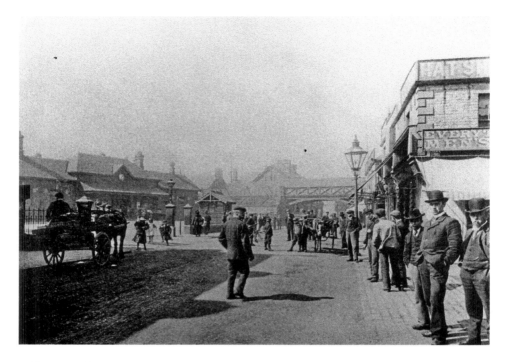

Railway Station

The first station was opened in 1847 by Blyth & Tyne Railway opposite the Fox and Hounds pub, close to the 'Marble Arch'. A new station was built further west with its frontage on Turner Street in 1867 and this was rebuilt between 1894 and 1896. In 1964, passenger services were suspended. The station was demolished in 1972 and a supermarket built there.

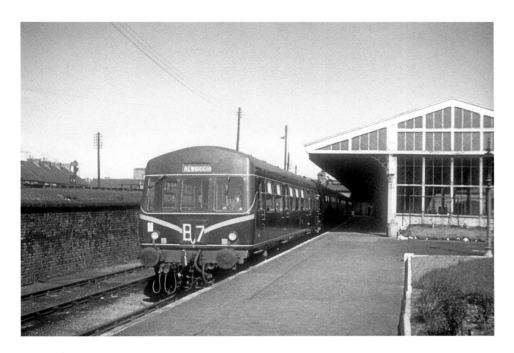

Newbiggin Train

Whether you were going to Newbiggin or Newcastle, you had to change trains at Newsham Station, as Blyth was not on the main line. Below, Mr Arthur Ayton (*third from left*), the Blyth Stationmaster, shows some of the railway staff the gardens, which won second prize in the annual station gardens competition in August 1960.

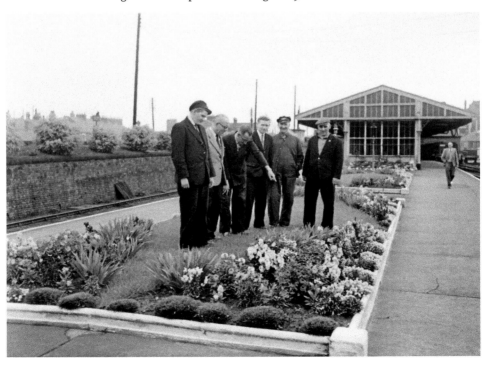

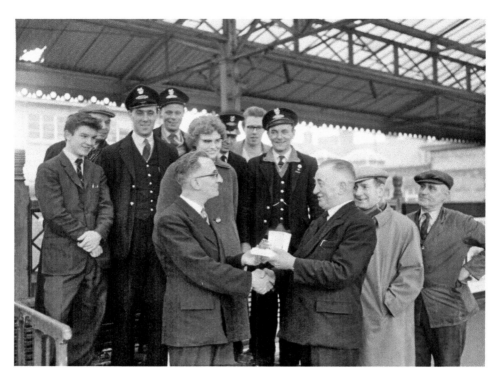

Station Platform

Mr Ayton retired as Blyth Stationmaster in February, 1961, and was presented with a gas table lighter from his colleagues. Making the presentation is the Relief Stationmaster, Mr J. Smith. A local band, De Acorns, on the station platform in 1964. Dave 'Holly' Holland, sitting in the wheelbarrow (centre) found fame as the singer with sixties band Toby Twirl.

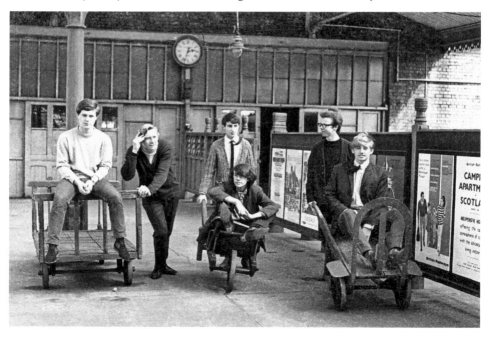

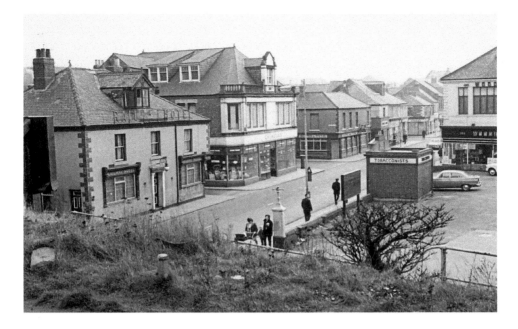

Turner Street

Here Turner Street is seen from the rail bridge. On the left is the Railway Hotel, Chisholm's White Shop, the Blyth & Tyne pub and Temple's shop. The station entrance is on the right, with Finlay's tobacconist's kiosk and Woodhouse's furniture shop. Built in the 1860s, the Railway Inn, opposite Morrisons, became the Pullman in 1974 and recently changed to become the Last Orders. It is notable for the wood carvings above its windows, known as the 'Eight Stages of Inebriation' (inset).

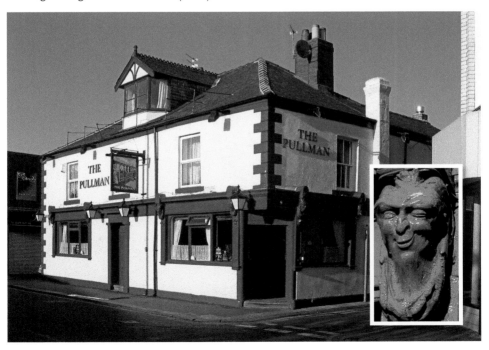

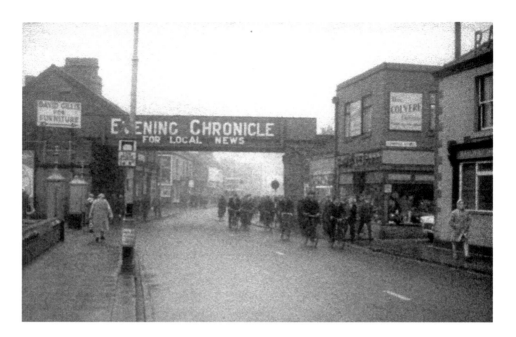

Rail Bridge

Dividing Turner Street from Regent Street, this rail bridge led to the South Side staiths. Above are some Blyth shipyard workers on their way home on their bicycles in the 1950s. Below, in November 1961, the Royal Northumberland Fusiliers march under the bridge on a recruiting drive.

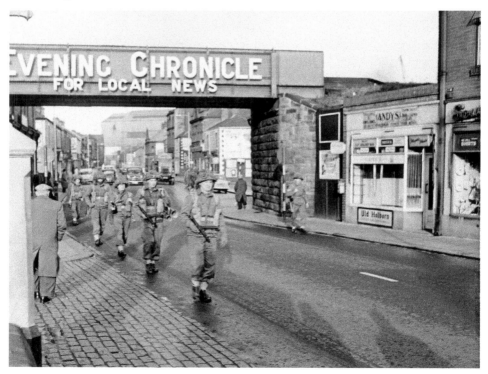

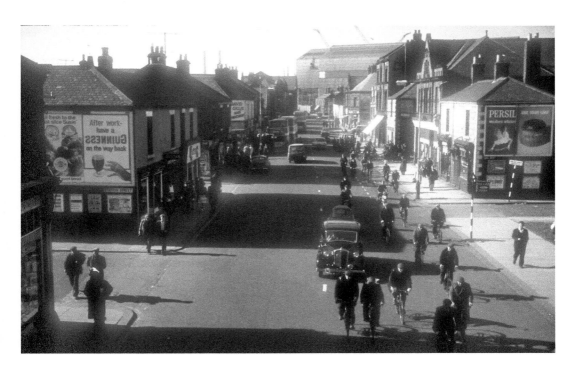

Regent Street, 1962

Here Regent Street is seen from the bridge, with the cranes and fabrication shed of Blyth shipyard in the distance. Below, crowds gather in the shipyard for the launch of the *Monksgarth* in December 1959. Regent Street is on the right, with Shy's the butcher's shop on the corner of Goschen Street.

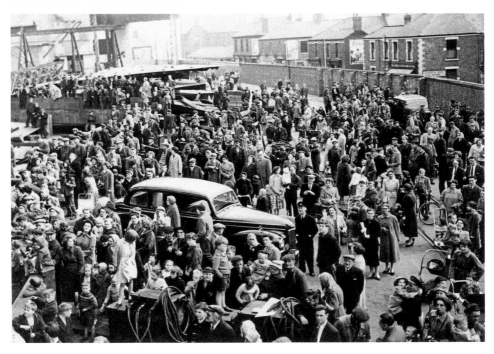

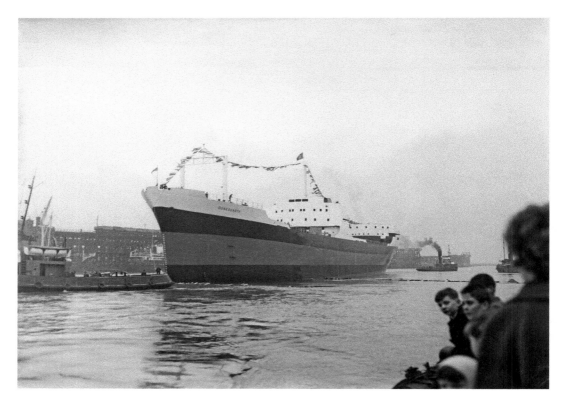

The Dukesgarth

The *Dukesgarth* was launched from Blyth Dry Docks & Shipbuilding Company on 13 April 1961. This was the last of four ships built for the St Denis Shipping Co. She was an ore-carrier of 10,670 gross tons and was completed in September 1961.

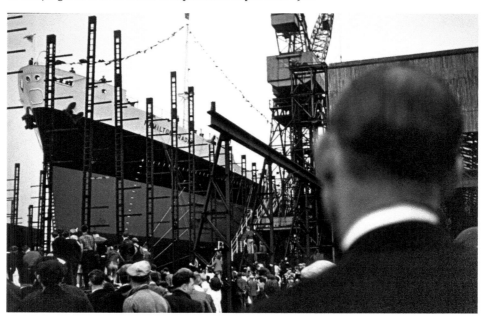

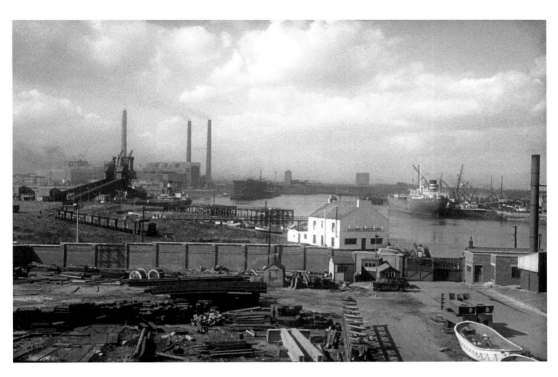

The West Yard

Blyth shipyard's West Yard, with the power station under construction. The ship lying at Bolckow's is the *British Admiral*. A vehicular ferry ran from near the Golden Fleece to Cambois near Bolckow's shipbreaking yard.

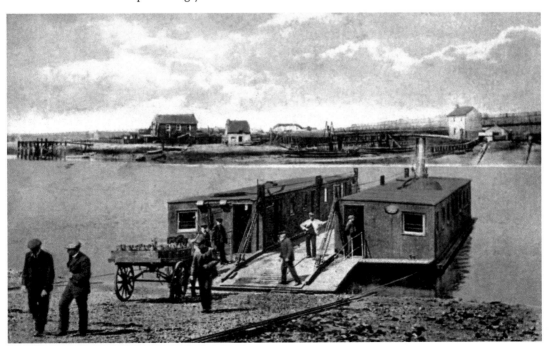

The Cambois Side

This is where you paid the ferryman. The vehicular ferry was replaced by a launch in 1964, but by the mid-1990s it was taken out of service.

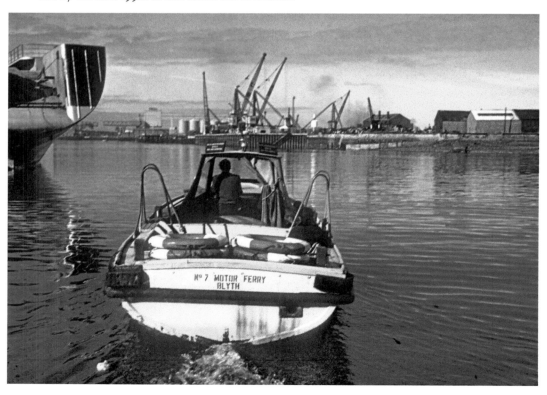

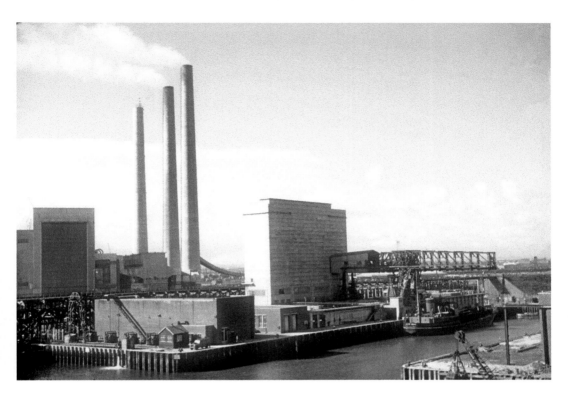

Blyth Power Station

The Power Station and the Ash Dock with the *Sir Fon*, which took the ash to the dumping ground, three miles off Blyth. Below is the grain berth, where a Russian vessel is unloading. To the right is a Russian submarine, at Battleship Wharf being dismantled.

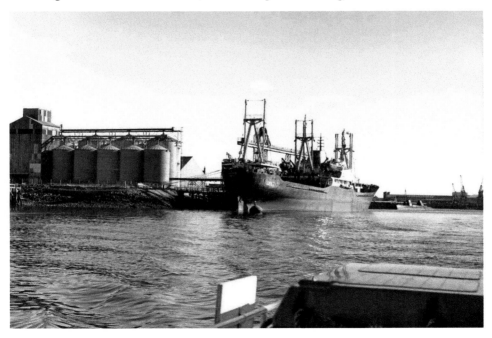

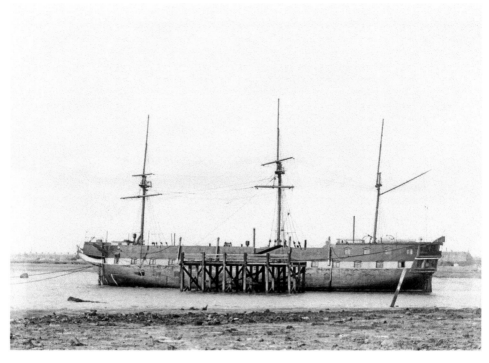

Southampton

The first ship broken up by Hughes, Bolckow & Co., Ltd. at Blyth was the training ship *Southampton*, just after they moved here between 1911/12. Watched by children on Ritson's Jetty, another vessel makes its last voyage, passing the North Blyth staiths where two colliers are loading. The shipyard is on the right.

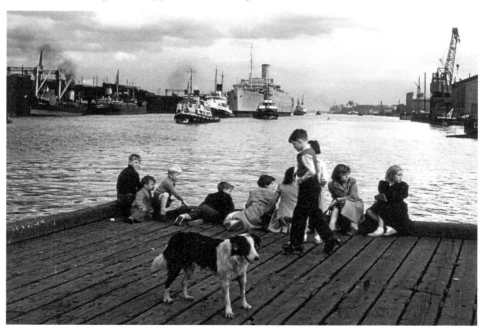

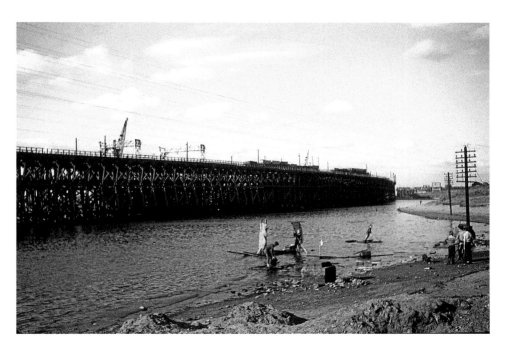

North Blyth Staiths

Behind the North Blyth staiths, children have made rafts for a race. On the other side of these staiths is the *Corsound*, loading coal after colliding with the staiths in March 1966.

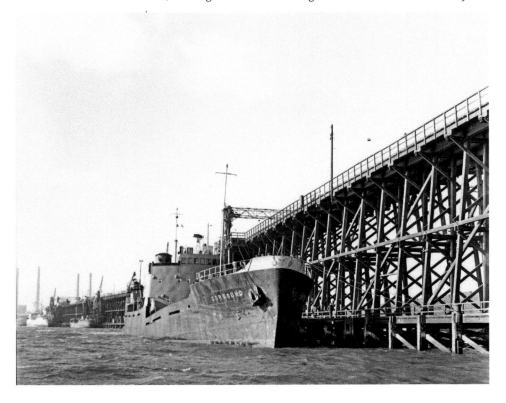

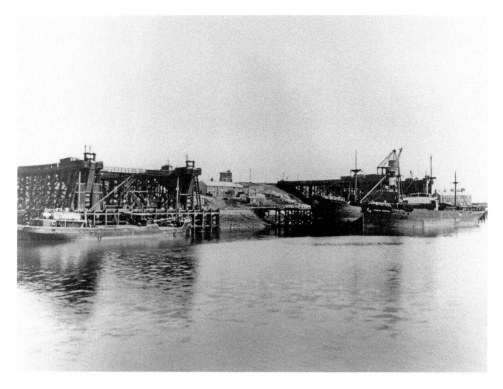

Cowpen Coal Company Spouts and *Britta*

Downriver from the North Blyth staiths were the Cowpen Coal Company spouts and a block of houses with a pub, the Seven Stars, in the middle of them. Below, the Swedish vessel *Britta* is towed to the dry docks for repair after a collision in the English Channel in 1961.

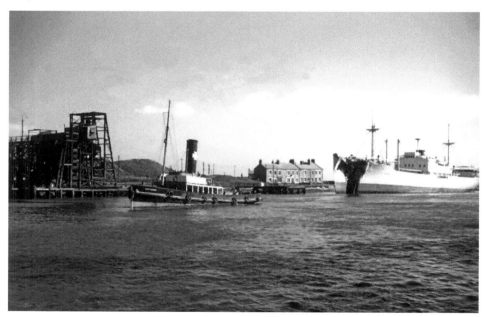

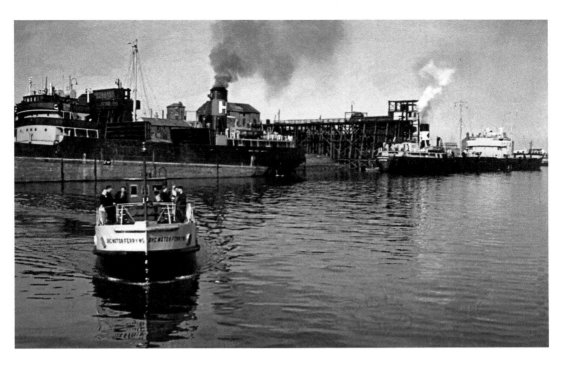

The Mid-Ferry

Another ferry, the Mid-Ferry ran from near the spouts to the High Quay at Blyth. No. 5 Ferry was built at Blyth shipyard. Below are passengers waiting for the ferry on the Blyth side, High Quay, in 1960.

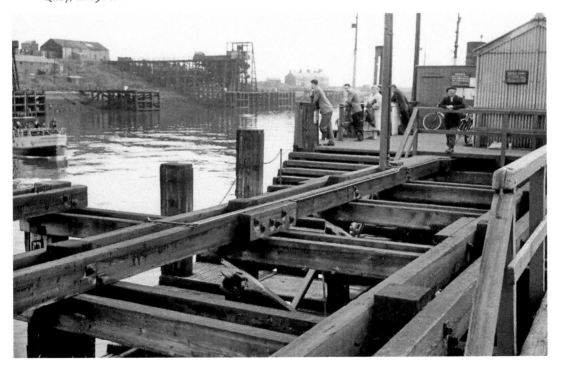

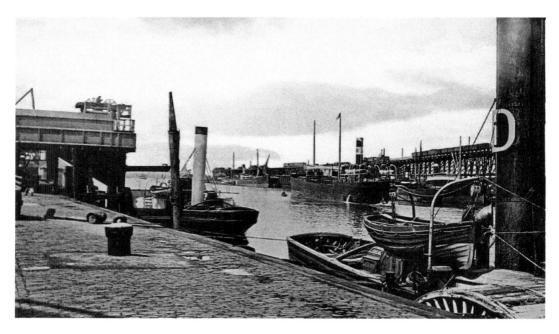

Tug Boat Landing

The tug boat landing on High Quay in the 1920s. Today this area is home to the Blyth All-Weather Lifeboat, which has been run by local volunteers since 2005. On the right is Battleship Wharf with cranes and warehousing built after the Port of Blyth took over the disused area in the 1990s.

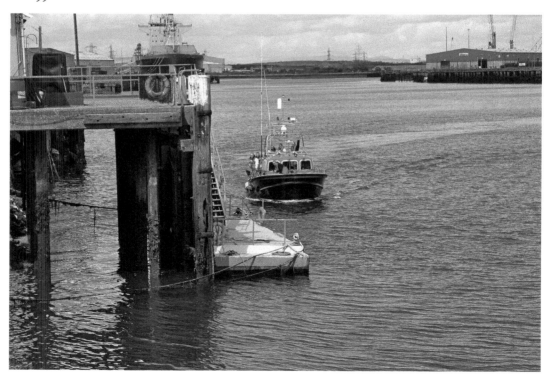

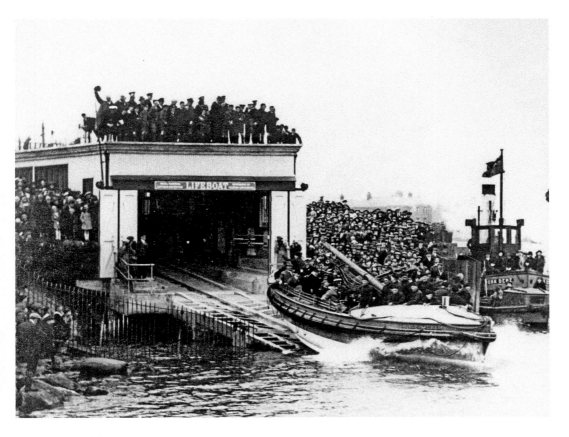

Blyth Lifeboat

Although Blyth has had a lifeboat since 1808, it wasn't until 1921 that a motor lifeboat came into service. Above is the *Joseph Adlam* being launched from the new lifeboat house after the naming ceremony in May 1922; below, the RNLI inshore lifeboat *Jennie B* on Lifeboat Open Day, July 2009.

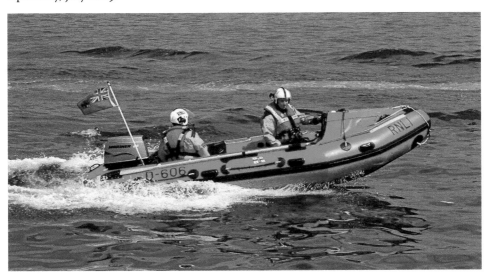

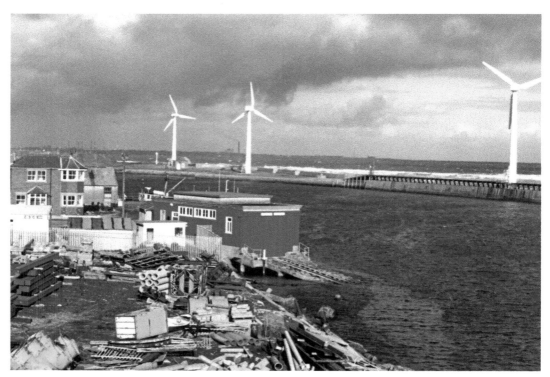

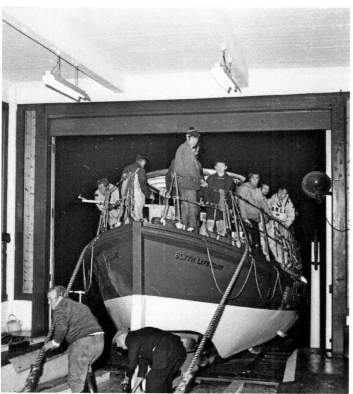

Lifeboat House and RNLI
Winston Churchill
The 1921 lifeboat house
in 1995. On the left is
the Pilot's Watch House
and to the right is East
Pier, with the wind
turbines that were erected
in 1992. The *Winston
Churchill* launched
from this boathouse to
rescue three men and an
eleven-year-old boy from
a disabled cabin cruiser
Disqualification on 11
October 1970. A new
lifeboat house is currently
under construction.

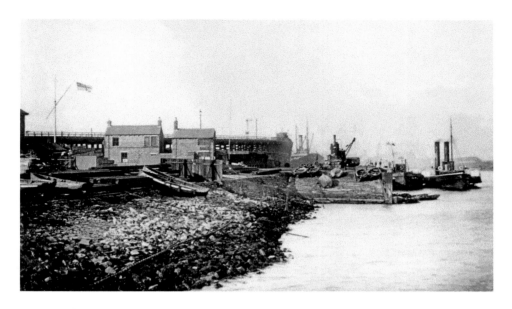

Pilot House

The start of the construction of the lifeboat house in 1920 to house the new motor lifeboat, which was ordered in 1913 but held up by the First World War. To the left of the flagpole is the corner of the Volunteer Lifesaving Brigade headquarters and watch house, then to the right stands the Dock Master's office, with the old Pilot House to its right. Behind are the South Side staiths. below is the Volunteer Lifesaking Brigade headquarters in the South Harbour.

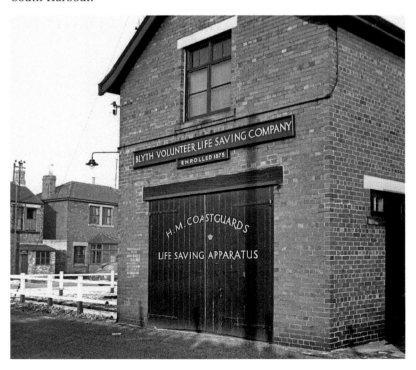

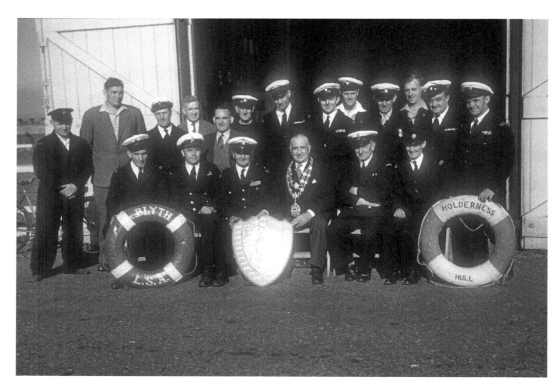

Blyth Life-Saving Brigade

The Mayor of Blyth (Alderman Geo. Colpitts) and members of the Blyth Volunteer Lifesaving Company with the Board of Trade shield they won for their rescue of the crew of the *Holderness* in 1959. Below, a much earlier photograph of the Lifesaving Brigade being presented with medals for bravery. Notice the lady reporter, Margaret Jane Smith, who became Deputy Editor of the *Evening World.*

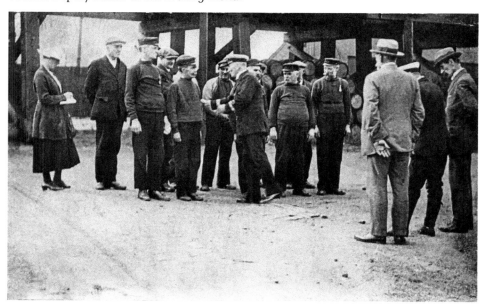

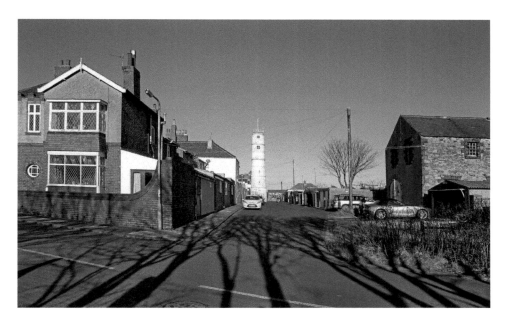

Back Bath Terrace *c.* 1920

The stone building on the right was the original headquarters and watch house of the Blyth Voluntary Lifesaving Brigade. The building of the railway embankment to the staiths obscured the line of sight from this building so the brigade moved to new quarters in the South Harbour in October 1912.

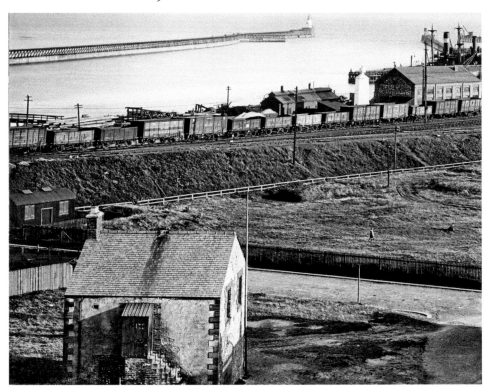

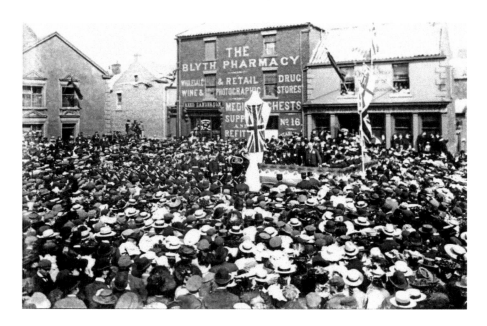

The War Memorials

About 100 yards from the old Lifesaving Brigade Headquarters are Blyth's three war memorials. Revd Swindells reads the service at the 1959 Remembrance Day parade. The memorials were brought together in 1950. The Celtic cross is the Boer War memorial, unveiled in 1903, in front of what is now the Post Office bar.

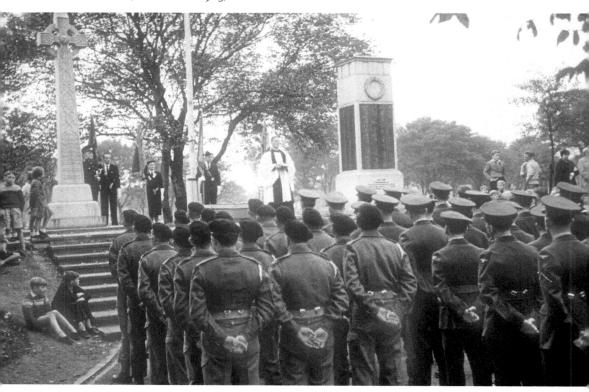

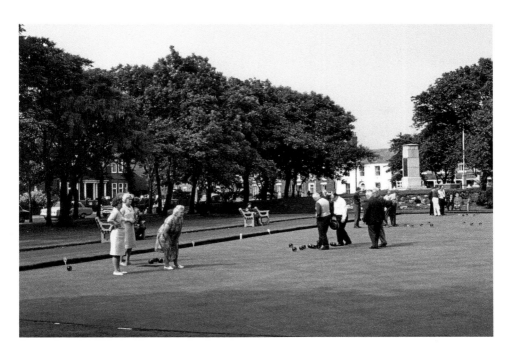

Bowling in Ridley Park and Park Road
Behind the memorials are two bowling greens. Leading from Ridley Park towards the town centre is Park Road. The buildings on the left-hand side, with the exception of two shops where the car is parked, were demolished and new houses built in their place.

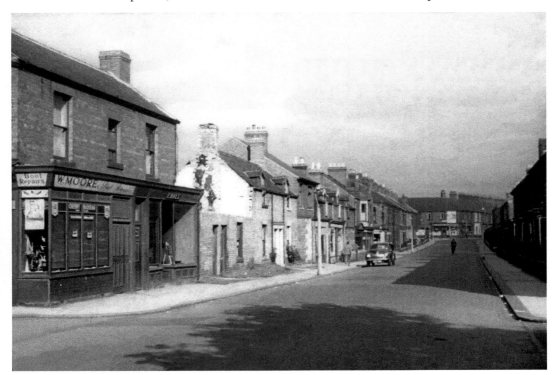

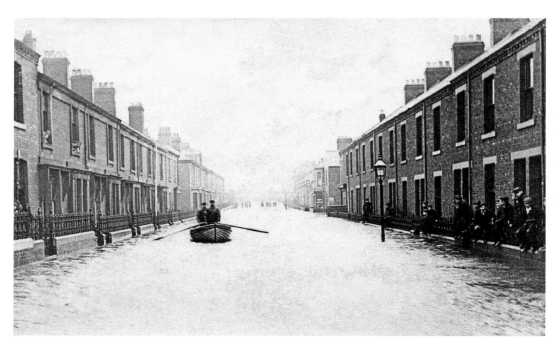

Park Road Flood

In October 1900 the residents of Park Road, then known as Folly Road, were stranded in their houses during a massive flood. This was the worst flood known in Blyth, and until the 1970s, when a new drainage system was built, the road continued to have problems. In 1959 the flooding was not so bad, as can be seen in this view looking towards Beaconsfield Street.

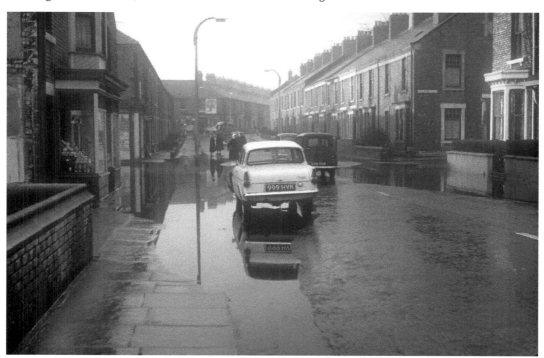

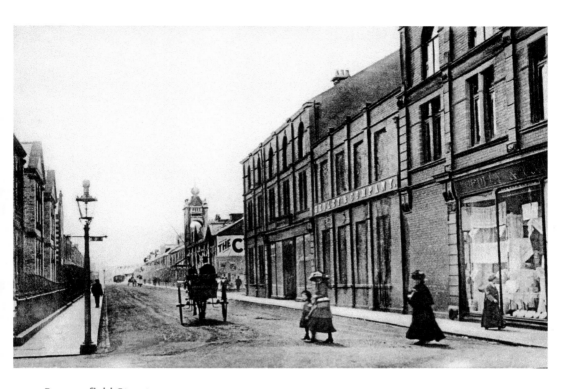

Beaconsfield Street
Looking towards Park Road, on the left are the Library and the Thomas Knight Memorial Hospital, with John Hedley's department store, right, and the Empire Electric Palace Cinema.

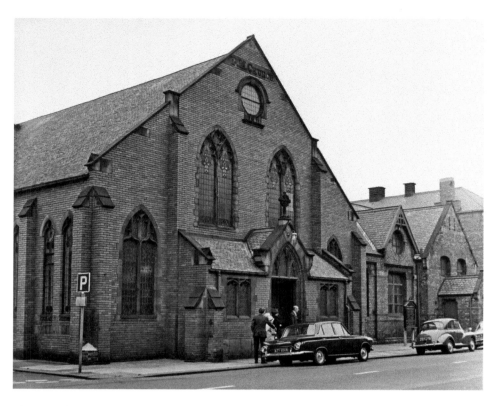

Phoenix Theatre

On the corner of Beaconsfield Street and Carlton Street stood the Primitive Methodist church from 1913 until 1968, when it became home to the Phoenix Theatre. In 1995 the theatre was rebuilt and opened again in April 1996.

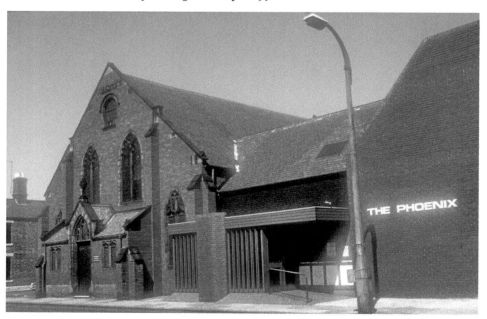

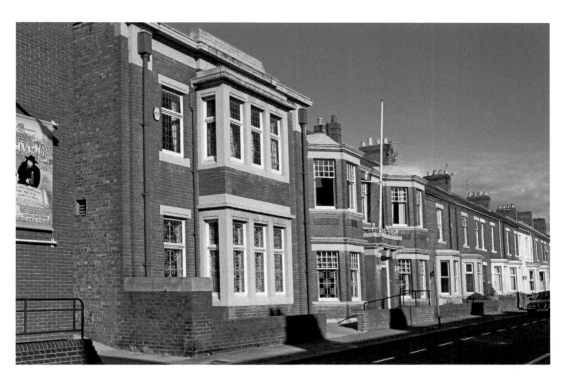

Masonic Buildings

Next door to the theatre are Blyth Masonic Buildings, opened in 1898 and still in use today. Recently they have been made available to the public for private functions and are licensed for civil marriages and partnerships. No. 29 was the Steward's house, shown here in 1910.

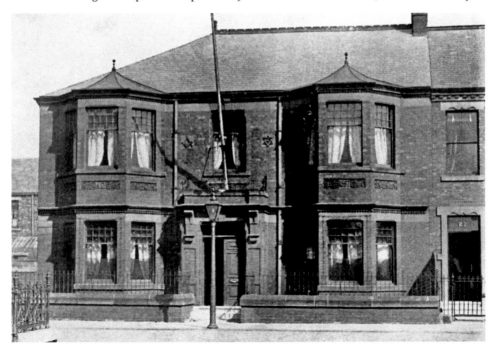

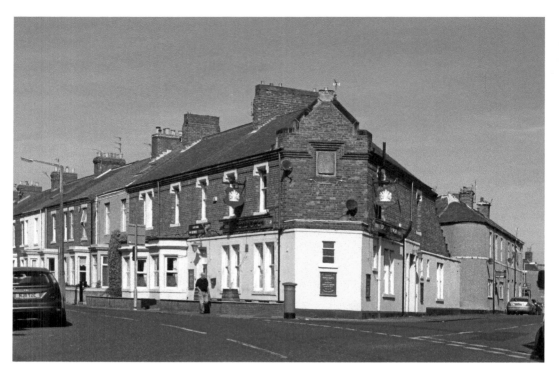

Royal Tavern

Near the junction of Plessey Road and Park Road was an inn known as the Waggon, probably built in the 1690s. Just after this photograph was taken in 1888, its license was transferred to the Royal Hotel, Beaconsfield Street, which changed its name to the Royal Tavern in February 1950.

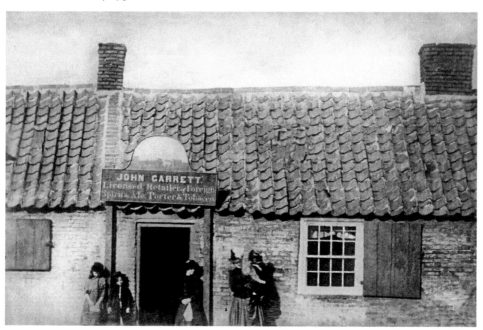

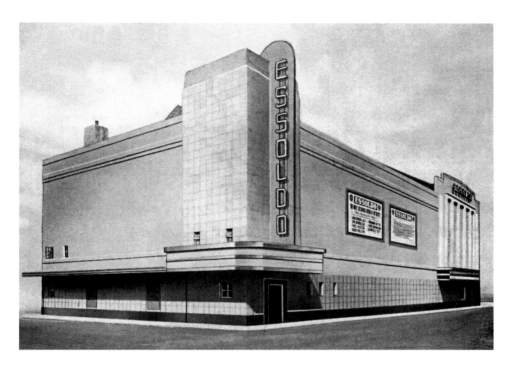

Essoldo Cinema

Sol Sheckman bought the Empire in Beaconsfield Street and built the Essoldo Cinema on the site in 1937, the name derives from the names of his sisters, Esther and Dorothy, and his own. The Central Methodist church was built on this site in 1988, opening in March 1989.

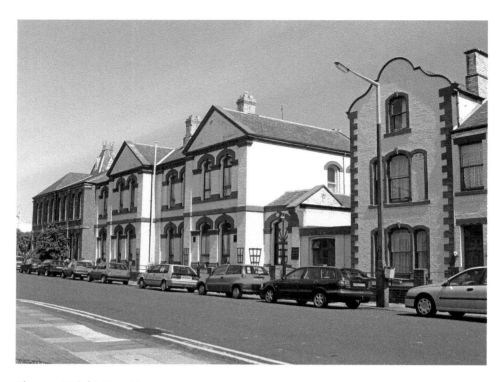

Thomas Knight Care Home

Opposite the Central Methodist church was this care home, which opened in 1988, having been a hospital for 100 years previously. In 2003 a new care home was built on the site.

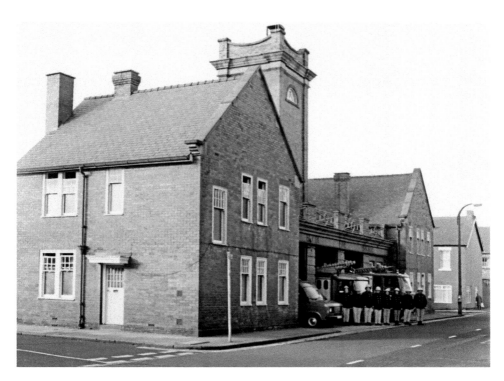

Fire Station
This fire station, in Union Street (running parallel to Beaconsfield Street), was opened in 1924 by 'Bob' Smiley MP and closed in 1986 when the brigade transferred to the new station at Cowpen Road.

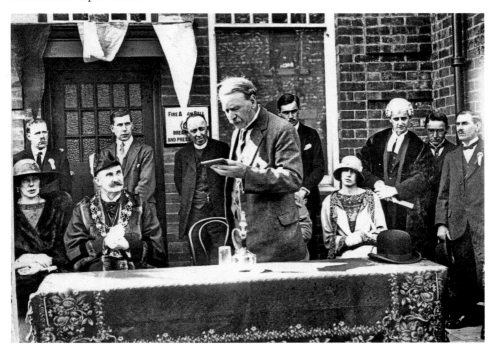

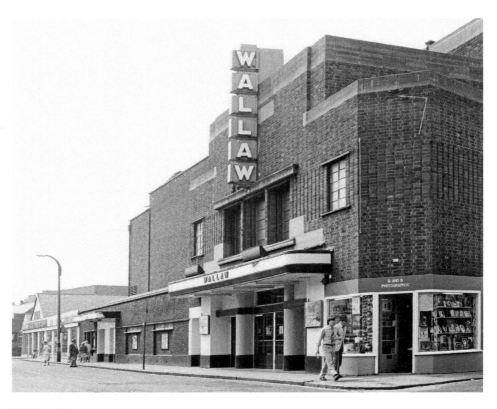

Wallaw Cinema

Built on the site of a circus, the Hippodrome, this cinema opened in 1937 and closed in April, 2004. For the premier of *Zulu* in 1964, the local TA formed a guard of honour outside the cinema. Eddie Milne, MP, inspects the guard.

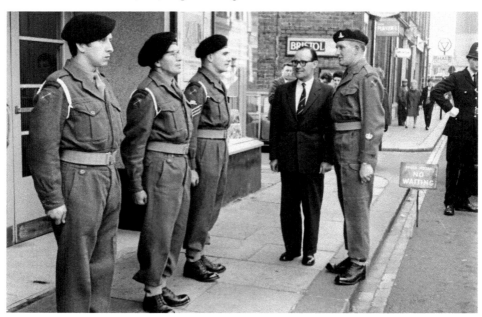

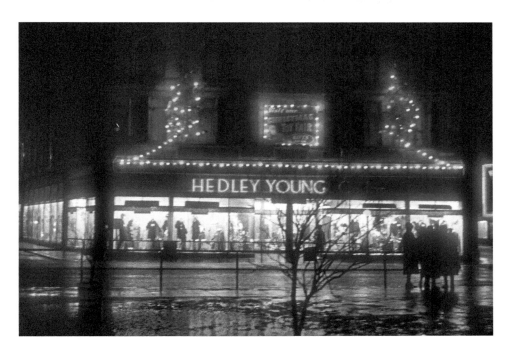

Hedley & Young's

John Hedley went into partnership with S. K. Young in his new (in 1895) shop on Bridge Street, where Beaconsfield (*left*) and Union Streets begin. They were noted for their fashion shows, using their staff as models.

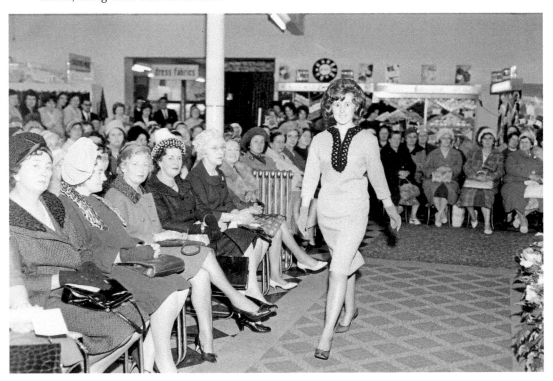

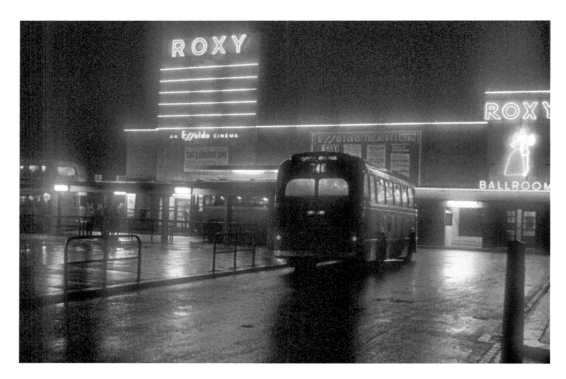

The Roxy

On the other side of the bus station, opposite Hedley & Young's, were the Roxy Cinema and the Roxy Ballroom. The cinema was built on the site of the Hippodrome, built as a roller-skating rink. The Royal Rink was converted to the Hippodrome cinema by Bill Tudor (*left*), who had previously run a circus in Union Street, shown with the Hippodrome staff in about 1930.

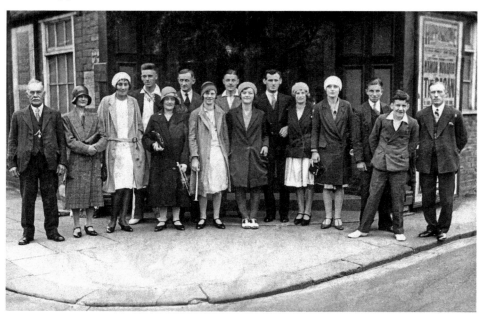

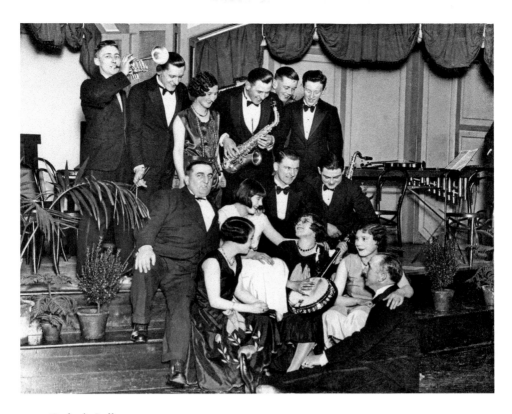

Tudor's Ballroom
Bill Tudor built a dance hall next to his cinema. The gentleman with the saxophone is Tommy Bell, who went on to lead his own band at the Roxy Dance Hall.

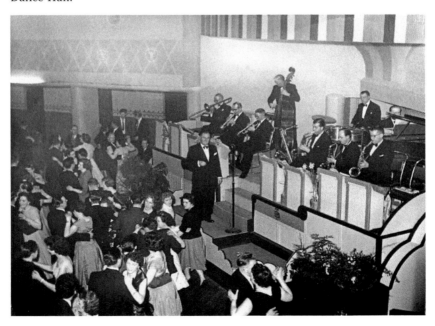

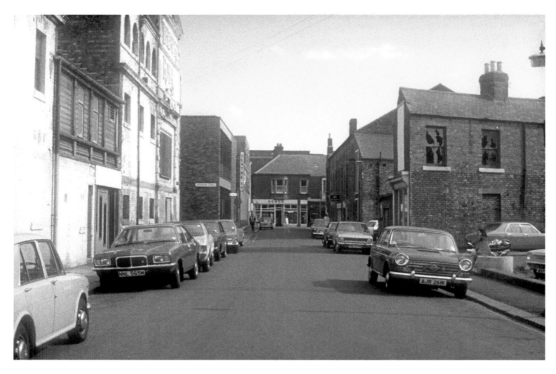

Theatre Royal

On the left is the 'new' Theatre Royal, in Trotter Street, with Centre 64 youth club on the corner of Jefferson Street (named for the first Theatre Royal manager, Arthur Jefferson, Stan Laurel's father). The building in the right at the bottom of the street is the original Theatre Royal. Below is the stage of the Theatre Royal with the cast of *New Moon*, in 1962.

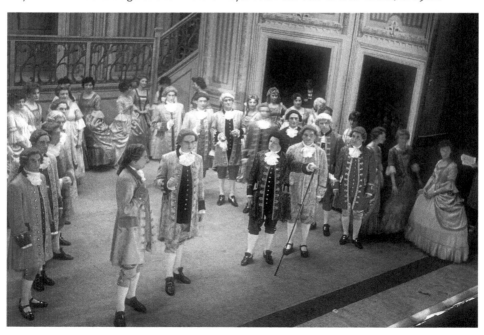

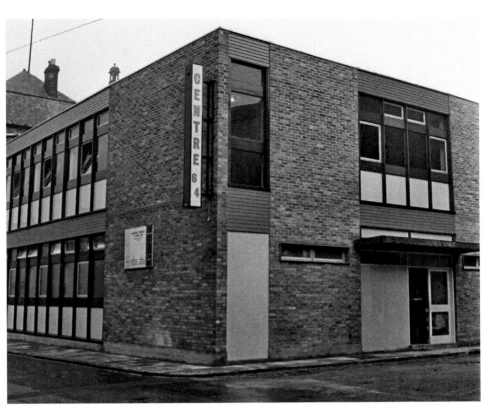

Centre 64
The Central Methodist Youth Club, now part of the Keel Row shopping centre, was opened on 31 October 1964. In May 1972, members of the club won this cup in a fashion competition.

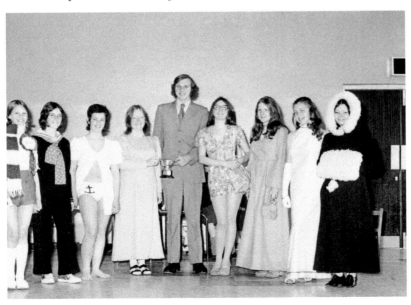

95

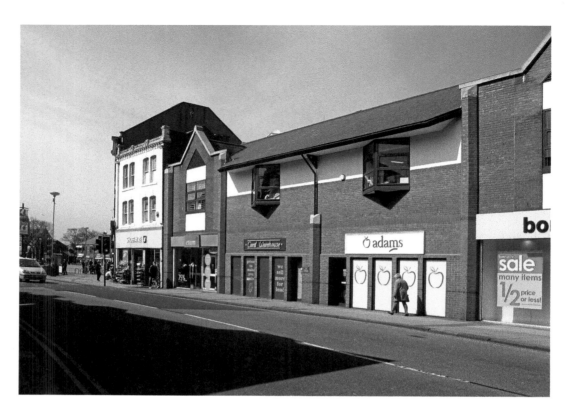

The Keel Row

The Keel Row shopping centre on Waterloo Road was opened in 1991 on the 26 June by the Mayor of Blyth, Eric Tolhurst. These shops on the right were replaced when the shopping centre was built. The sign for the old Theatre Royal is on the corner of Trotter Street at the junction with Waterloo Road. In the middle are the Central Buildings.

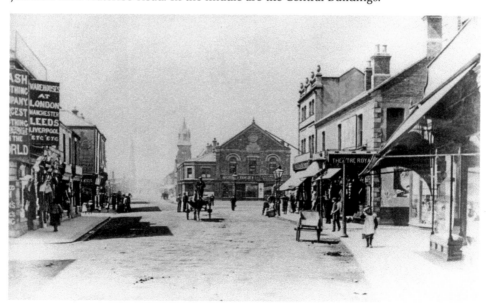